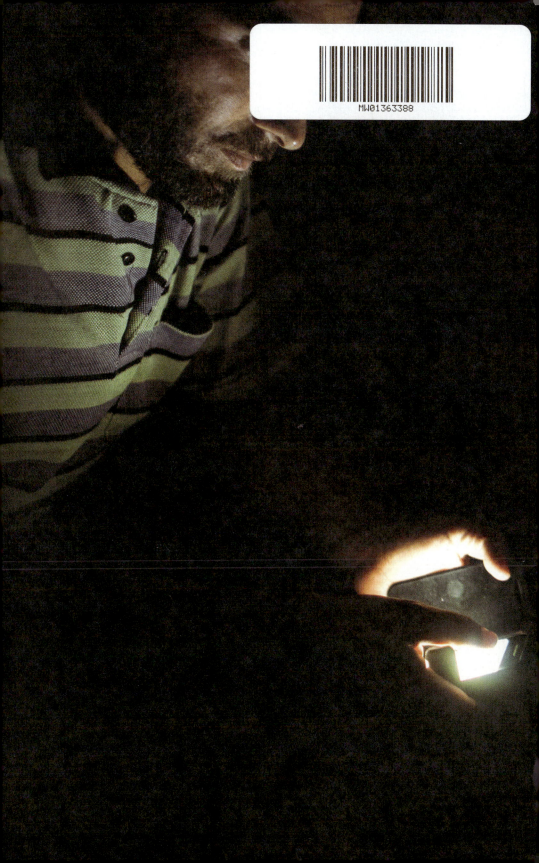

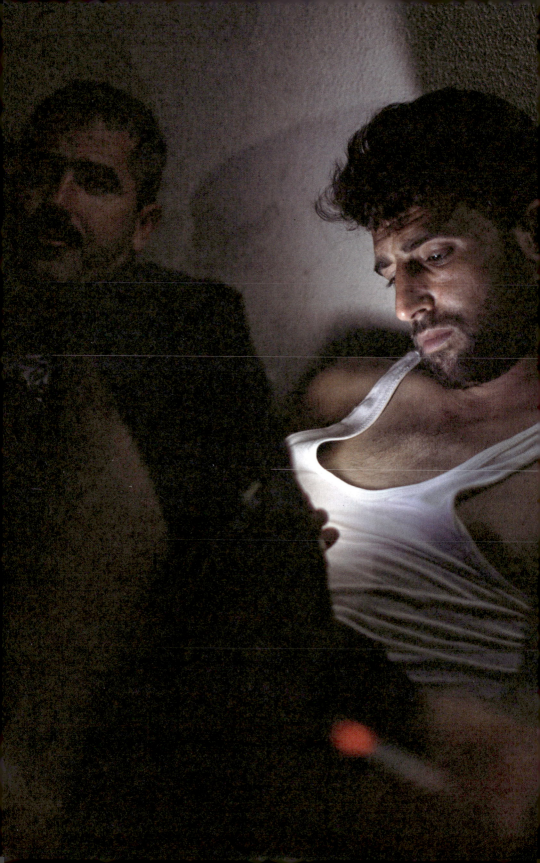

No it's far off. And yes
people are in the shelters
don't chat with me.
God be with you
I cannot chat anymore

And what do they want?
What are they lacking?
First thing we need are the shoes. Secondly, we need rice, lentils, wheat, sugar, oil, and ghee. The guys want to start cooking by themselves and distribute food to the different settlements

—

Where are you? Every time you can, talk to me so I know you are safe
Yes now things are OK the bombing has stopped. I...

As soon as the van comes I will send it.
Weren't you supposed to send the medicine to Arsal? I am waiting. The situation is becoming somewhat bad. When will you send it brother? God willing. It is very important.

—

Even if we become like this we will liberate Syria...

God willing

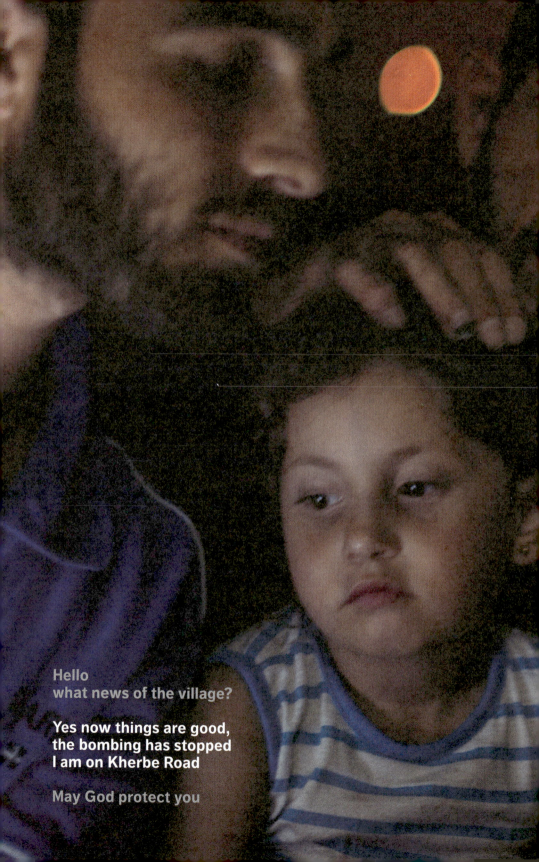

Hello
what news of the village?

Yes now things are good, the bombing has stopped I am on Kherbe Road

May God protect you

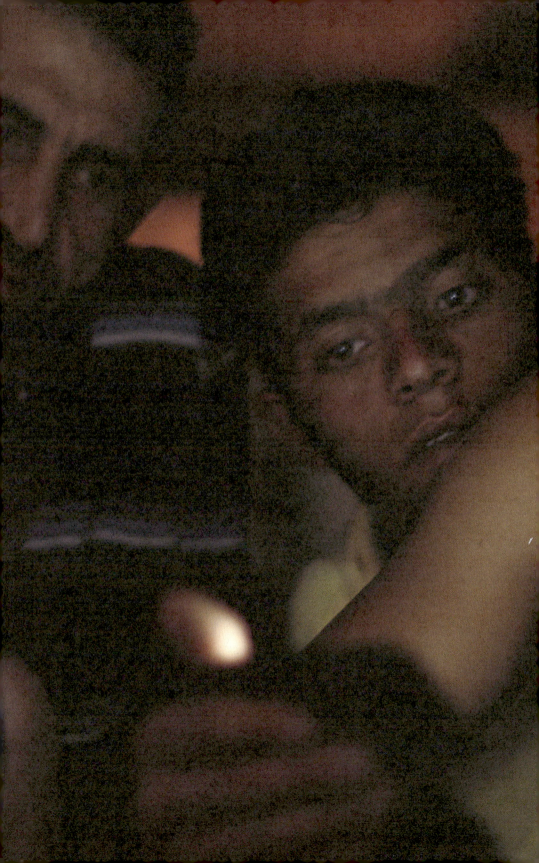

TEXTING SYRIA

"In Akkar, Lebanon, 16 Syrian refugee families live in tents erected within a disused slaughterhouse near the Syrian border. At night, the men get on their mobile phones and text home, hoping for news from friends and relatives under siege. I photographed them in the dark, lit only by the glow of the screens. Afterwards, I photographed their phones and had the messages they hadn't deleted (for security reasons) translated from Arabic to English."

Liam Maloney *is an award-winning photojournalist and videographer represented by Polaris Images. A broad focus of his work is the plight of refugee populations caught in conflict, both in East Africa and the Middle East. He lives in Toronto. liammaloneyphotos.com*

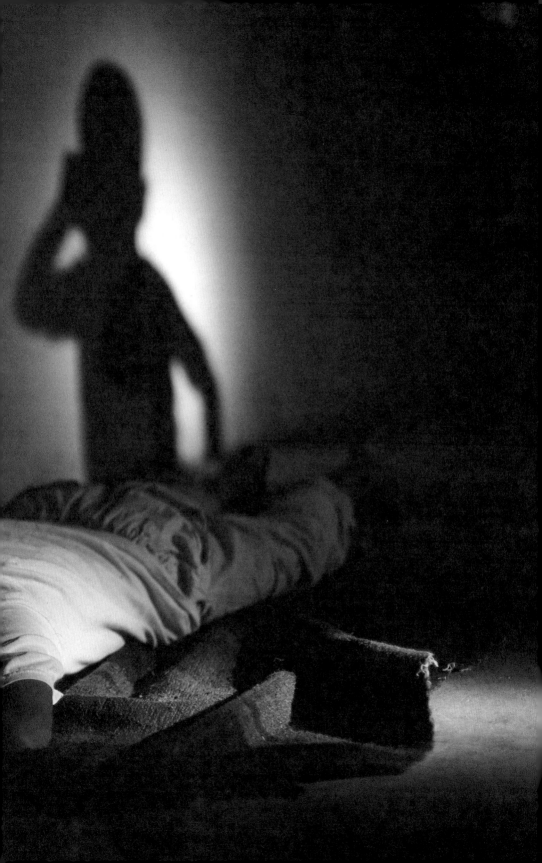

1	Texting Syria LIAM MALONEY	
15	Gutless MICHAEL WINTER	
17	What Does Murderous Hate Ask of You? NAVNEET ALANG	
19	Explaining Canada to Americans ALEXANDRA MOLOTKOW	
22	Shelf Esteem: Sheila Heti's Emotional Associations As told to EMILY M. KEELER Photography BY LORNE BRIDGMAN	
34	Family Secrets DURGA CHEW-BOSE	
41	Three Eulogies: Wendy O. Williams, Valerie Solanas, Cookie Mueller ALEXANDRA MOLOTKOW Art by ADRIENNE KAMMERER	
52	Xavier Dolan's Great Expectations CALUM MARSH	
56	Touching the Dead: Spooky Winnipeg TOM JOKINEN	
62	Second Tongue JOWITA BYDLOWSKA Photography by KRISTIE MULLER	
65	Tabloid Fictions: A Watch in the Night BILLIE LIVINGSTON	
	Blood and Guts in Charm School LYNN CROSBIE Illustrations by LOLA LANDEKIC	

81	**Album VI (2007)** LUIS JACOB
90	**'I Bet Your Mama Was a Tent-Show Queen'** CARL WILSON Art by MICHAEL COMEAU
104	**James Salter's Blue Moves** SARAH NICOLE PRICKETT Art by HUGH SCOTT-DOUGLAS
113	**Fire in the Unnameable Country (Excerpt)** GHALIB ISLAM
117	**A Few Things I Know About Monique (Excerpt)** CHRISTOPHER FREY
123	**Nessie Wants to Watch Herself Doing It** PATRICIA LOCKWOOD
125	**Why We Should Treat Poetry Like Painting** LINDA BESNER Photography by NADIA BELERIQUE
130	**Battling Bitterness with Bogeymen: An Interview with George Saunders** NAOMI SKWARNA
136	**The Cyclist as Cannibal (Excerpt)** RICHARD POPLAK
142	**Shelf Esteem: Joseph and Amanda Boyden On the Corner** As told to BRETT MICHAEL DYKES Photography by WILLIAM WIDMER
150	**'I Was a Directionless Acid Freak Until I Found Cooking': Four Cookbook Authors Talk Shop** MEREDITH ERICKSON with NAOMI DUGUID, JENNIFER MCLAGAN, and PETER MEEHAN

Hazlitt #1, Winter 2014

Editor-in-chief
Christopher Frey

Art Direction
Jeremy Laing

Senior Editors
Jordan Ginsberg, Alexandra Molotkow

Assistant Editor
Scaachi Koul

Design and Production
Charles Yao

Podcast Producer/Comix Editor
Anshuman Iddamsetty

Editorial Assistant
Isabel Slone

Contributing Editors
Navneet Alang, Linda Besner, Jowita Bydlowska, Lynn Crosbie, Michelle Dean, Tom Jokinen, Emily M. Keeler, Billie Livingston, Heather O'Neill, Sarah Nicole Prickett, Chris Randle, Naomi Skwarna, Michael Takasaki, Carl Wilson

Contributors
Durga Chew-Bose, Brett Michael Dykes, Meredith Erickson, Ghalib Islam, Patricia Lockwood, Calum Marsh, Richard Poplak, Michael Winter

Cover Design
Renée Alleyn

Art, Illustration, Photography
Nadia Belerique, Lorne Bridgman, Michael Comeau, Luis Jacob, Adrienne Kammerer, Lola Landekic, Liam Maloney, Kristie Muller, Dave Murray, Hugh Scott-Douglas, William Widmer

Project Manager
Meghan MacDonald

Website Art Direction
Monnet Design

Website Development
Digital Echidna

Largely produced at Capital Espresso, Toronto
Printed by The Prolific Group, Winnipeg, Canada

Special Thanks
Melanie Britton, Kristin Cochrane, Erin Cossar, Ariane Elfen, Britt Harvey, Kiara Kent, Elizabeth Kribs, Janine Laporte, Cassie MacKenzie, Stephen Myers, Philip Monk, Krysta Oben, Peter Ramsey, Scott Sellers, Paul Terefenko, The Gabardine, Chris Young, James Young

Distribution
Hazlitt is distributed internationally to bookstores, newsstands, and specialty retailers. To carry the print edition of Hazlitt in your store or locate a copy near you please contact: hazlitt@randomhouse.com
To order a copy online visit www.hazlittmag.com

Advertising
For both online and print advertising, and special opportunities, please contact:
hazlitt@randomhouse.com

ISBN 9780771038235
All rights reserved. The use of any part of this publication reproduced, transmitted in any form or by any means, electronic, mechanical, photocopying, recording, or otherwise, or stored in a retrieval system, without the prior written consent of the publisher—or, in case of photocopying or other reprographic copying, a license from the Canadian Copyright Licensing Agency—is an infringement of the copyright law. CIP: Library and Archives Canada Cataloguing in Publication available upon request. LOC: Library of Congress Control Number: 2013951445

Copyright © 2013 Hazlitt/Penguin Random House Canada

Hazlitt is produced by the Digital Publishing Department at Random House of Canada. This is a McClelland & Stewart book.

Hazlitt / Penguin Random House Canada
One Toronto Street, Suite 300
Toronto, Ontario
M5C 2V6
www.hazlittmag.com

President & CEO: R. Bradley Martin
SVP, Director, Business Development Online & Digital Sales Strategy: Robert Wheaton
Director, Digital Publishing: Christopher Frey

Hazlittmag.com

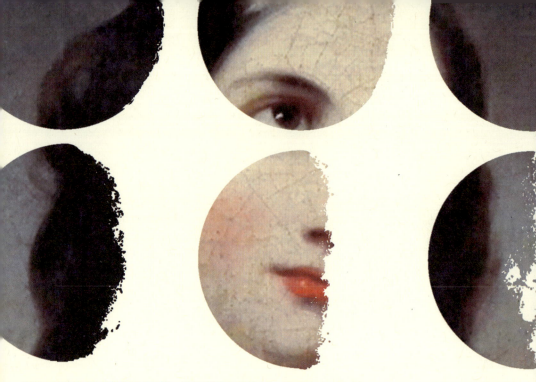

"AN IMPRESSIVE NOVEL, **CAPTIVATING, INTENSE** AND **FULL OF SURPRISES.**"
Times Literary Supplement

shortlisted for
The Man
Booker Prize
2013

THE LUMINARIES
ELEANOR CATTON

McCLELLAND
& STEWART

Gutless

MICHAEL WINTER

We were having one of those arguments where every answer compounds the fury and so I ended up storming out the door for fresh air and deciding, at this hour, to grab the oars and go fishing. This was at the end of a warm day in Newfoundland. I rowed out to catch cod in a manner that has been conducted for five centuries: a weighted jigger fed to the bottom of the sea and then pulled up one arm's length. I let the quarrel evaporate and the jaws of the land talk to me and reassure me that I was good and welcome. I had been reading, every day, a poem by Czesław Miłosz called "Love," which asks you to look at yourself as you look at distant things. And this was my way of healing myself from accusation. The earth was patting me on the back and telling me I would be alright. As I write this I'm wearing a down vest that's a little too small, and when I zipper it up it does the same thing: it gives me a reassuring hug.

I was sitting in a traditional Banks dory. It was getting on for dusk and other fishers who had access to barometric pressure readings said they'd best be off. Their boats rose up and ploughed through the North Atlantic back to safe harbours. I was soon left alone on the sea trying to catch my daily limit. It was a beautiful evening, the sun just sinking over the land that I had rowed away from. I had that feeling that astronauts say they have as they exit the gravitational pull of the earth, that I was leaving home. It is a terrifically cheap form of space flight, this rowing out to sea.

There are a couple of widows on our road and I give them each a fish as I row back to the house where my wife is now, putting our son to bed. The women are delighted with the fish—though one is disappointed that hers is gutted but head on. She wants fillets. So I take the time, after I've pulled the dory up past high tide, to flense the meat from the backbone and slip the white flesh into a plastic bag.

I can see the widows' houses, and our house a little further on, now that the upstairs hall light is on. She is good at flipping hurt and anger into a neutral position and starting afresh.

But here I am, feeling sorry for myself, with this clear filament in my hands that ravels invisibly down 50 storeys to within a metre of the floor of the sea. As if I'm dangling a rope from a skyscraper hoping to lure something from the sidewalk, or snag, archaeologically, an insight from another sediment of

Michael Winter

time. I catch the fifth fish and haul him in hand over hand. I pull the fish's great head over the gunwale and use my clunker to stun him. This clunker is a small length of birch that I now keep in the boat after a humpback whale hit me. I had been out earlier in the summer and saw the dorsal fin of a whale some ways off. Then he disappeared. Then he rose like a helium balloon and lifted my dory off the water. He presented me with his big dark eye. It terrified me. A marine biologist friend told me I wasn't making enough noise. I have no motor, and the whale, in his exuberance for catching caplin, forgot about me.

 I gutted this fish and, as I lifted him back into the sea to rinse his innards—the gulls racing in to collect his intestines and liver and heart—his body gave a tremor and he slipped out of my grasp. I reached for him but he was swimming now, the vents of his belly flaps flaring out as he sank deeper, back to home. He had no idea he was gutless, that he would never reach home. Something about his path connected with an emotional dryness I was feeling. This return home, bereft of the luggage of the heart.

 A bank of clouds rose up over the northern coast and swallowed the sun. Then the wind noticeably changed direction and I remembered the barometric pressure warning. Out on the horizon the sea rose a fraction, as though the entire hemisphere was lifting a little to pour the ocean onto me. Then a swell. There are waves which are a local phenomena caused by winds we are familiar with. But a swell is something that can originate from the other side of the ocean, from Portugal or France. I hauled out my oars and swung the dory for home, feathering the oars through the crests of this swell. Small whitecaps tore out of the uniformity of the sea. I rowed. I had just done an ayahuasca ceremony and I knew what to pray for. I had a son and a wife and who was I kidding with this self-reliant life. I had widows to feed. The idea of a dangerous life. The greater risk is trying to return home, gutless, but valiantly seeking a better sense of oneself through the eyes of those who love you. I thought of that wind from France—I had recently visited the World War One battlefields. I had seen the great arch of Thiepval and, from a distance, not been impressed. But when you walk up to that arch, stand inside it, you realize it is not just a monument to war, or the Battle of the Somme, but a frame for the sky. That frame, with all the names of the missing and those missing are in the sky. It makes me think of a poem by Patricia Lockwood, about an arch, and all I can remember of it is her comparison to a woman's armpit. It is easy enough to love, and difficult to allow love in. To allow love into one's orbit is to be vulnerable, it is to understand that one is not a fixed star but a varying light, not a source but a relay station influenced by the love of others. The old story of you are everything.

What Does Murderous Hate Ask of You?

NAVNEET ALANG

You cannot extricate Sikhism from a single, defining question: What is demanded of you? It runs through the entire faith, but its genesis is probably the story of the Panj Pyare, one of the founding myths of the religion. In the late 17th century, Guru Gobind Singh, the final living Sikh leader, asked of his flock who would literally give his or her head for the faith. Daya Singh stepped forward and was led into a tent from which the sound of a sword swinging was heard, followed by a trickle of blood running out from under the fabric. Four more men followed to answer the call, and each time the same subsequent hint of a beheading.

It was, of course, in the classic way of the religious tale, a ruse—goats, not men, had had their heads cleaved off. Guru Gobind Singh later emerged from the tent hand-in-hand with the "five beloved ones," and it was then that five markers of the religion—the familiar turban among them—were put into practice. The point of the fable? Henceforth, Sikhs would always have to visibly mark themselves as Sikhs, never permitted to shy away from their responsibility to stand up for the faith or to fight for the oppressed.

What a twisted cosmic joke, then, that such visibility, just over a year ago, led to the murder of six Sikhs by a white supremacist in a temple in Oak Creek, Wisconsin. Paramjit Kaur Saini, Prakash Singh, Ranjit Singh, Satwant Singh Kaleka, Sita Singh, and Suveg Singh Khattra, all dead not just because of how they identified, but because of how easily they were identified. And so, once again, nearly 30 years after burning tires were placed around the necks of Sikhs during the Delhi riots while the police looked the other way, the same question, tinged with history's inescapable influence: what does murderous hate demand of you?

I don't know the answer. How could I? Six people who looked like my extended family were murdered in a house of peace and worship. And I find myself unexpectedly using the strangest of words to now describe my relationship to Sikhism: we.

We. Us. These aren't words I'd ever used before to talk about religion. I was raised in a house in which Sikhism, like the painting of Guru Nanak tucked away in a bedroom upstairs, always lingered around the edges, but never featured prominently. My mother believed, but only in a general idea

of God; my father preferred biology labs, the Romantics, and Sufi poetry to Sikh scripture. As a teen and into my twenties, when asked what religion I was, I used to answer "my parents are Sikh," both because it was honest and because I used to be exactly the sort of aggressive, Nietzsche-quoting atheist I've since come to detest.

But my sudden turn to that particular pronoun stems from the impossibility of that kind of privileged distancing—that dismissive rejection of culture, heritage, and community—in the light of a hate-filled mass murder. Moving through the usual second-generation immigrant questions of identity is one thing; responding to people like you being killed is quite another altogether. So there it is. "We." We Sikhs. That's who I am now.

In another way, though, identifying as Sikh is also about the same demands of visibility. There's always been an odd irony that, despite the fact that a smiling Sikh shows up in every idealized image used to represent multiculturalism, Sikhs remain somewhat unseen, or at least misunderstood. I can't tell you the number of times in my life I have stood in rooms of (mostly white) Canadian writers and academics—the intelligentsia, if you want—and had to spell out the most basic ideas of Sikhism to those I thought should know better. When the Oak Creek massacre happened, news reports lit up to "explain" Sikhism, as if one of the world's major religions were some mystical cult. It sounds like melodramatic hyperbole, but it literally took some of us being murdered for "mainstream society" to give a shit about who we are—or indeed, to consider that we might also be part of this so-called "mainstream."

At the same time, it also took this act of violence to force an end to my own ambivalent dance around an identity. It's not so much that I chose to admit "who I really am"—such essentialist ideals help no one—as much as I decided to lay claim to something in which I was implicated. My answer to the question "what religion are you?" isn't so defensive anymore. I no longer feel like I have the luxury of such evasion, and instead, with my body and the voluntarily worn markers of my kind, I must represent. I must stand for something, and speak as part of something, too.

What does murderous hate ask of you? It demands that you take a side—that you identify. It demands you eschew the nonsense of a "neutral" or "normal" identity and claim a definite one. I don't quite know what the implications of that are—whether there's a lesson to be learned about identity politics, the oppositional nature of defining oneself, or, god, even "radicalization." But this is the situation. You must decide what kind of markers to place on yourself. And when only death makes one's identity visible to others, what choice do you have but to achingly say, joined with others in loss, "I am Sikh"?

Explaining Canada to Americans

ALEXANDRA MOLOTKOW

Americans don't know much about Canada. Canadians probably don't know much about Canada either, compared to how much Americans know about America, because Canada doesn't consider itself as important to know about. Nonetheless, we know more about Canada than Americans do.

I can't fault Americans for not thinking more about Canada. And I don't presume that any Americans will bother with the following, in which I address some misconceptions about our country and provide a more accurate account of how we live. If you're American, and you've made it this far, I appreciate your willingness to expand your horizons. Perhaps you'll decide to immigrate.

First of all, yes, Canadians do talk funny, and in a less dignified manner than in any American region. But this is because Canadians are not accustomed to talking. Canadians generally communicate by means of the McQuiggan, a long strip made of bear hide. When two Canadians want to have a conversation, they suspend the McQuiggan by their teeth and flick it with their fingers in a kind of Morse code. Except that we don't have Morse code here. We call it "tapping."

The McQuiggan keeps our discourse civil and prevents interruption. Most other communication is made by hand gesture. An upturned palm affirms; a downturned palm negates. Pointing is illegal, and can lead to jail time. Jail time in Canada is called "time out."

The Canadian diet does include bacon, bagels, and maple syrup, but these are consumed during ritual brunches known as Vaniers, and then vomited up collectively—an important peer bonding exercise in a country where all public celebration must be pre-approved by the Office of the Bonhomme de Neige. Most of the time, Canadians subsist on a simple diet of berries, wafers, and bone marrow, as well as sushi for the sake of diversity. Wonder Bread is often served as a dessert.

To keep the peace, the Canadian government subsidizes a number of "social valves" for our ghastlier appetites. The streets of all Canadian villages are lined with cement huts so that, for a dime, any Canadian with the urge to dance may quell this urge in private. (Public excoriations are administered to any Canadian who makes eye contact with one exiting a hut; regular eye

contact entails only a month of language lessons.) For a larger fee, Canadians can access "yelling ranges," equipped with soundproofing headgear and a "silent room" where users can reflect on their shame in the aftermath.

Every year on Canada Day, Canadian villages host Dignity Fairs, which are sponsored by Labatt. Adults drink beer dyed yellow to match our national symbol (a smiley face with no mouth), while children enjoy toothpicks dabbed with bacon grease. Afternoons are spent playing Canada's national sport, called The Virtue. A player, standing in the middle of a circle, is told not to do something. He or she then refrains from doing it. Applause is frowned upon, but crowd members sometimes indulge in a "wave" of shrugs.

The Canadian unemployment rate is 7.3 percent, and work is concentrated primarily in agriculture and witchcraft. Canadians whose employment is terminated through no fault of their own enter suspended animation at government-run labs known as Verve Generators. Their résumés are circulated through a mailing list known as the Bourgeois Sovereign, until a landowner agrees to take them on. However, recent cutbacks have forced some Verve Generators to close, pushing the unemployed into community service positions—organizing gravel at our public gravel pits, or going door-to-door inquiring after people's health—for which they receive a small stipend.

Canadians value the nuclear family. While it's true that some kin units live in igloos, most rent space in multi-family circus tents and sleep collectively in flannel mounds. Incest is unusual, but occurs; children of incest are called Hyperselves and treated with polite disdain. Because daycare is not subsidized, roving gangs of child bandits are a pressing social problem, for which our Conservative government has yet to pose any worthwhile solution.

Statistically, Canada is less religious than the United States, but most Canadians still belong to the Canadian Orthodox Church, if only to uphold tradition. Sunday service generally begins with a round of "Sometimes When We Touch" or "Wreck of the Edmund Fitzgerald" (other hymns include "Log Driver's Waltz" and "As the Years Go By"). Sermons consist of inoffensive platitudes and each service ends with the collective shaking of hands, followed by ritual purification by Purell.

Asked to name a Canadian icon, Americans might point to Neil Young or Ryan Gosling or Peter North. True Canadian icons include Gordon Lightfoot, Peter Gzowski, and Harry Chapin—not a Canadian, but much loved in Nova Scotia, where his legacy is honoured at an annual festival in Ovens Park, where "singing, storytelling and good-natured rabble-rousing are nearly nonstop."

And yes, healthcare is publicly funded. It's great.

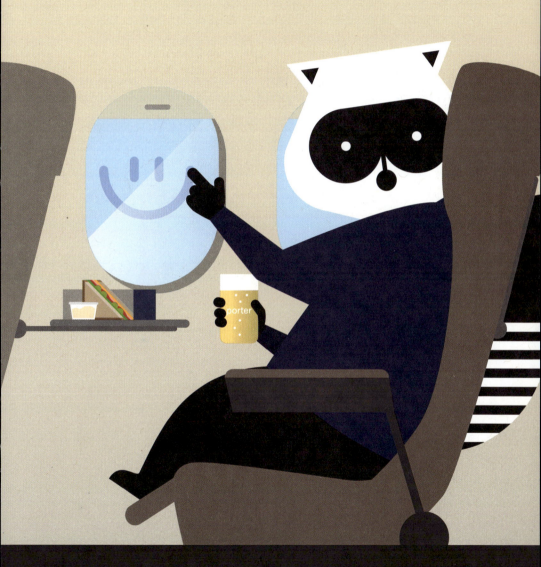

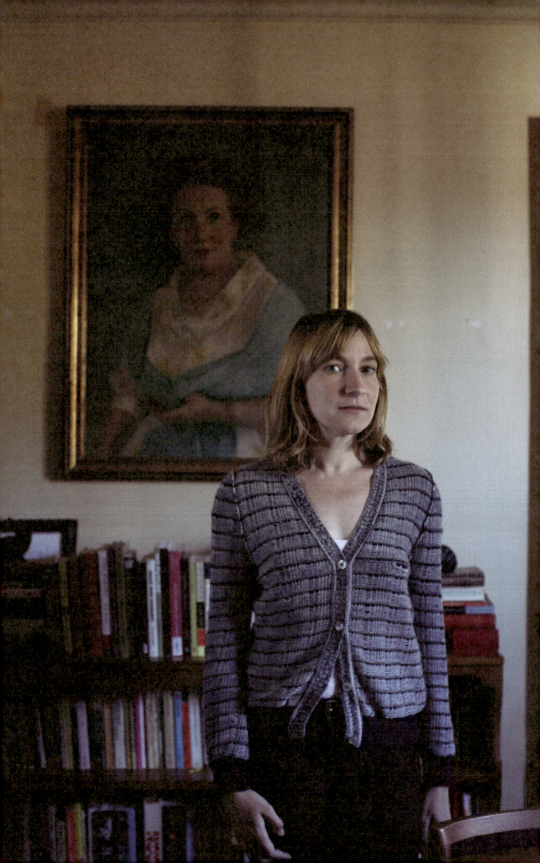

Shelf Esteem: Sheila Heti's Emotional Associations

As told to Emily M. Keeler

A regular look at the bookshelves of writers, editors, and other serious readers, in their own words.

PHOTOGRAPHY BY LORNE BRIDGMAN

Sheila Heti

Sheila Heti's library is in the middle of her apartment. Blue light filters in through a window that overlooks a tree canopied street. Various editions of her most recent and much discussed novel, How Should A Person Be?, *are stacked discreetly on the top of one of her vintage book cases. We circle around the cleared surface of the dining room table that she uses for a desk as she describes her various treasures. She mentions Feldman, the dog Heti recently adopted with her boyfriend, but it's their pet rabbit that causes her books the most grief.*

The place is a mess. I haven't adjusted to having a huge Rottweiler. The dog wants to play with the cat, but playing means putting her in his mouth and shaking her around. It's a full-time job keeping them apart. It's chaos. I had not put any books on the bottom shelf for a long time, because they would all get eaten by the bunny. But I realized I need the space. So badly.

Only this weekend did I ingeniously figure out what to do, which is to put the canvas here on the bottom bookshelves. Because the rabbit rips them up—she eats the books if given the chance. I can show you the one I gave her as a decoy. I've finally just given it to her. You can see her work, it's beautiful. She's really got that rabbit thing of being afraid, but sometimes she'll come out and say hi.

There's only a few things that are organized. I just put books wherever they go. I have a pretty good memory for where books are on the shelves. But lately it's been kind of confusing, because I just have too many of them.

This hutch was the last piece of furniture to come to this room. I'm working on a book that's an adaptation of the *I Ching*, so I have my *I Ching* books in here. I don't want the rabbit to eat the *I Ching* books, so I have to keep them behind glass.

Then there's this section, which is only a couple years old. I remember going to Jonathan Lethem's apartment in Brooklyn 10 years ago, and he has a shelf just for all the books that he'd published, and all the anthologies he'd contributed to. And it was a kind of fantasy that one day I would have that. And so, you can see: *Ticknor, How Should A Person Be?, The Chairs Are Where the People Go, The Middle Stories, We Need a Horse*, all my books are here.

These square blocks are Leanne Shapton's wooden books. She gave them to me as presents. They're really beautiful. I should actually have these facing out, but I don't have anything facing out because there's not enough space. Here are things I've contributed to, and then *The Believer* [the magazine for which Heti is an interviews editor]. And then I guess I keep some of the books that I like a lot behind glass here, but it's not organized. A lot of the books I like aren't on these shelves. And a lot of books that I don't necessarily like are here, but for a while I was just putting books I really like here. Maybe for rabbit-related reasons. I have all of my tchotchkes here. And my metronome from when I was younger and I wrote with the metronome on. For my first book, *The Middle Stories*, I would write like that. I think I found one rhythm I really liked, I think I tried different ones, but there was a pace that I really liked the most.

I guess this is another book-related thing. When *Ticknor* was published, they sent me the proofs and I had the front-page framed. Because I was so proud. I thought, *Oh, I'll be with Farrar, Straus, and Giroux for the rest of my life!* Which didn't

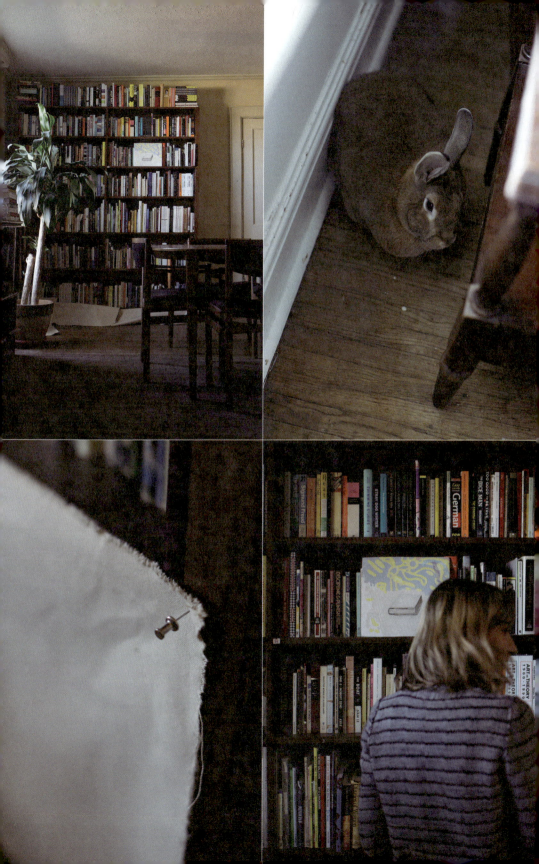

end up happening, because they rejected my next book. The rabbit, as you can see, ate at the frame.

This is a painting Margaux [Williamson] made for me when I was writing *How Should a Person Be?*, a couple years in, when I wasn't sure it was ever going to get done. And she made this as a way of inspiring me, or as proof that one day it'll be a book. And this brightness around it was part of her feeling about the book. There might be another painting that she made for the same reason. Oh wait. That's one she made for me when it was done, and this was the one she made for me when I was actually writing it. I should put this up.

My grandfather George Heti was a painter. I never knew him. This is one of his paintings—I always hung it in my room, since I was like, in my late teens or early 20s. I was thinking, *Oh, that's what you have to do to be a writer. Just sit in the chair.* It was kind of a reminder, or a token.

Margaux made this picture for me when I was having a hard time. She fantasized my ideal studio. And Naomi Skwarna stayed here once, as a housesitter, and she made me these things. These little felt flags.

I keep these paintings of my mother and my grandmother in my study. They're from Hungary, done by a professional portrait painter.

These books are newish. A lot of them are books that people sent me, like *The Flamethrowers*—which I loved. Or books that I ordered. I order books all the time. I made the decision a few years ago not to worry about spending money on books, that it was important to let myself buy books. But then I think I went a little overboard last year. Now I'll never be able to catch up. So I'm putting myself on a diet. A program. I'm just trying to read the books I bought last year. With Amazon and AbeBooks, it makes it kind of crazy, because you just read about a book and you can order it right away. And people send me a lot of books, from my being at *The Believer*, for blurbs, and this and that.

This is a great book. *Us: Americans Talk About Love*. Do you know this book? He talks to Americans about their relationships, and each one's a monologue. It's ordered by how long they've been together for, so one month to five years, to 40 years, to 60 years. It's such a good book, one of my favourite oral histories.

For some reason I have the *Diane Von Furstenberg Book of Beauty*. It's actually really good. I like her in this, I like her feminism. It's about everything: how to eat, exercise, makeup, body image, cosmetic surgery. From 1976, the year I was born. It's really good, I like a book that tries to do everything. I was doing her exercises for a while, and then my boyfriend started making fun of me. He said, "Are you doing your exercises from Diane von Furstenberg's Book of Buggery?" Every time I did the exercises he'd say that, and I had to stop. I really regret it; I really think I'd be in great shape now if I kept doing those exercises.

When I was writing *We Need a Horse*, my children's book, I bought a whole bunch of children's books. I have them over here. And books from my own childhood. Like the *Annie* storybook based on the movie. Oh whoa! There's a *Sassy* questionnaire in here. I said *Playboy* for "worst zine." I haven't seen this for a long time. Favourite show: *The Wonder Years*; Favourite Girl Band: The Culture Club—I don't know, I don't remember half of these

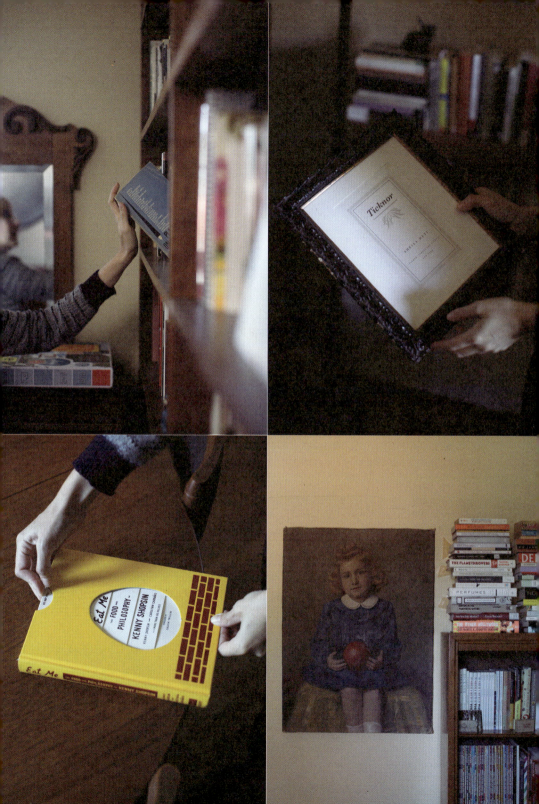

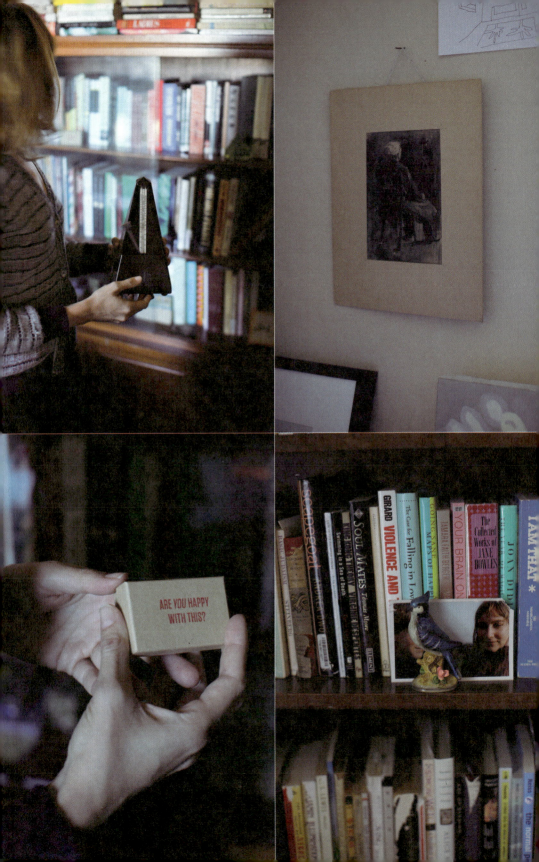

... Do you Like MTV: No; it's hard to know how sarcastic most of these are, or how serious the answers are.

This is the first draft of *How Should a Person Be?* It was all on notecards. I just carried them around with me. Different chapters, the plot, and I think some of them were just notes I had for myself while walking around.

This is a book that I really wanted, I remember spending a lot of money on it, $68. *The Creation of Psychopharmacology*. And I haven't even read one page of it, but I was sure that it was going to be an important book for me. That was ages ago, and now it's been ruined. I almost threw it out with the last cull, but then I deferred.

I like buying books, and having them. Even if I don't read them, it's comforting to have them around. I think I'm going to stop buying books over the Internet because I really feel like I don't have an emotional attachment with them. Like, *The Wedding Complex*. I bought that over the Internet, and I have no emotional association with it. It just doesn't call to me in the same way.

Also, I've tried to recreate that emotional pull. I saw *Dostoevsky's Occasional Writings* at City Lights bookstore [in San Francisco], and I wanted to buy it so badly. But I didn't let myself, because it felt too expensive at the time. And then I bought it few years later over the Internet, thinking I could recreate that feeling of association. But it doesn't have it, so I kind of ruined that.

This book was a big inspiration for me and Misha Glouberman when we were writing *The Chairs Are Where the People Go*. It's basically a recipe book, by Kenny Shopsin. He owns a diner in New York called Shopsin's. It's sort of like a greasy spoon with a lot of rules. So it's a recipe book, but it's also him talking about his restaurant. The photographs are so good, and I love his voice. Somebody recorded him talking, and I tried to do the same thing with the Misha book, where the recipes are the games, and his view of the world.

Leanne Shapton gave *Self-Help* [by Samuel Smiles] to me—or, I don't know if she meant to give it to me, but it's hers. I think this is obviously one of the most beautiful books that I have. I read it, too, and it's a really interesting book. This was the original use of the phrase "self-help," and so the first self-help book. It just talks about the lives of great men, and how they lived, and how you're supposed to learn from them. And now self-help is ... very far from that.

I have this stamp, I don't know what to do with it. *Are* You *Happy With This?* I wish I had students so I could stamp this on their pages. I feel like it's the question. It's passive-aggressive.

I guess I really treasure my Kenny Goldsmith books, actually. These were probably the first books I made an effort to get off the Internet. The one that I like the most is *Soliloquy*. Have you seen this book? He records himself talking for an entire week, and then transcribes everything he says. So word-for-word. He has no stage directions. No one knew he was taping, he just had a Walkman around his neck and he rigged up the headphones to record. It's seven acts with seven days. I love this book. You have the first thing he says in the morning, and the last thing he says at the end of the day. So on this day, the last thing he says is: "Pretty interesting, isn't it?" It's so good.

This is another favourite. *Manet and His Critics* is an incredible book about the

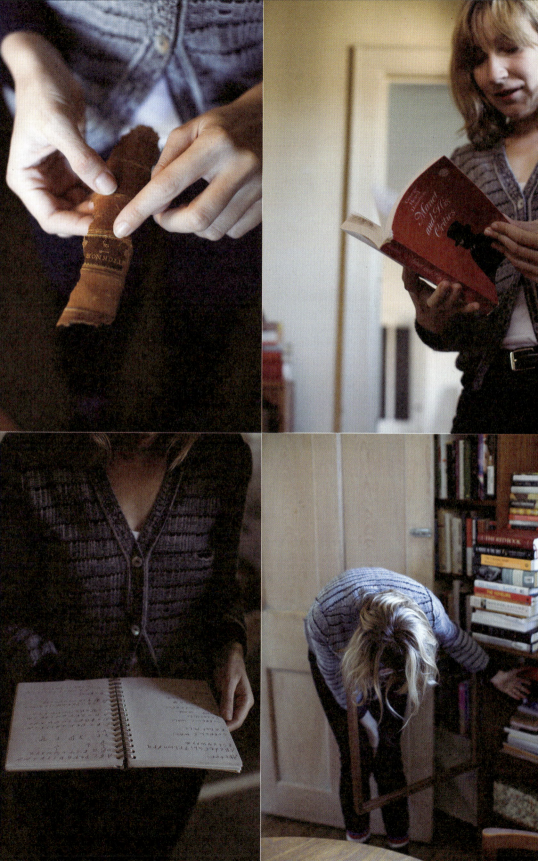

critics who wrote in the salon papers. You know, people would put out papers everyday? They all seem so stupid. Just how wrong they were about Manet, how they completely misunderstand him and how angry they get. It's really wonderful to see. You always hear that about art history, but it's so nice to see the actual documents.

Oh, this is the spine of the book by George Ticknor [Heti loosely based her novel *Ticknor* on *The Life of William Hickling Prescott*, a biography by Prescott's friend Ticknor]. I stole this book from the Green Room, you know, the Toronto bar that had that bookshelf? I found it lying around there. My rabbit tore the spine off, but I had to hang on to it; I just love that little star so much. I'd never heard of Ticknor. It was just so out of place. What was this old book doing among—you know, it's the kind of bookshelf where people just leave books for you to read. And I took it, I stole it, I brought it home. My friend was late, so I opened it up and I loved what I read. And I kept it on my desk for about a year. I never really thought—it never occurred to me until right now that this was the author's name on this spine, but for my book it became the name of the book.

I can't really remember books very well after I've read them, is the truth. I remember the feeling I had when I read it, but I usually can't remember much about what was in it. I never remember characters's names or anything. I feel like when I read a book it just gets assimilated into my brain. I think of that as a good sign, that it just becomes part of everything else. Though it's not so good for talking about books. I really like book-reviewing these days, because it's a way of trying to talk about books. It's the only way I've found myself—but even then it's not satisfying. You can't express love in a book review, not in the same way that you feel it. I wrote this review of Ben Lerner's book, *Leaving the Atocha Station*, and he thought it was a negative review. Which is weird, because to me, it's one of my favourite books I've read in years. But he had the impression that it was negative!

I don't know what else you want to know. It's hard because I don't have sections. I always have this experience of coming to my bookshelves and having a feeling in my body, that I want a book that will heighten or approximate that feeling. But I can never find the book. Kurt Vonnegut gets close sometimes. I usually end up thinking, *Oh, actually what I'm looking for is Kurt Vonnegut.*

Emily M. Keeler is a regular contributor to Hazlitt, *and the editor of* Little Brother Magazine. *She is the creator of* Hazlitt's Shelf Esteem *column.*

Family Secrets

Durga Chew-Bose

Reading *The Lowland* by Jhumpa Lahiri, I felt a long-abiding familiarity with the novel's premise—which I recognized from my father's stories—and with the author, a first-generation Bengali writer who was raised on the East Coast. And I discovered how it is to read when the emotional stake is not strictly your own.

ILLUSTRATION BY DAVE MURRAY

"At four Bela was developing a memory. The word yesterday entered her vocabulary, though its meaning was elastic, synonymous for whatever was no longer the case. The past collapsed, in no particular order, contained by a single word."

–*The Lowland,* by Jhumpa Lahiri

Visiting from Montreal two months ago, my father sat across from me in my Brooklyn apartment quizzing me on the names of Indian spices as he funnelled them from sticky plastic packets into labelled jars. *Kala jeera! Panch phoron? Cardamom, duh!* I guessed some and confidently yelped the Bengali names of others,

and when I was stumped, I tried to change the subject by suggesting I boil water for tea. The spices had been piled in my pantry for three years; a gift from my mother and stepfather who, hoping I might show an interest in cooking, had thoughtfully assembled a starter pack, so to speak. I have since used the cumin, some bay leaves, the turmeric, and mustard seeds—though I am tentative of the latter as they pop in hot oil and my stove sits at a precarious slant.

It was July and muggy, and we had turned off the fan to avoid dusting my dining area with spices. Seeing as he was only in New York for a short visit, I worried this was an awfully unspectacular way for my father to spend his vacation. And yet, the more I proposed alternatives—"The MOMA, Baba? A walk and some ice cream, Baba?"—the more he smiled and shook his head as if affectionately saying, *nice try*. Consolidating cardamom for his 27-year-old daughter, it turns out, was the only thing my father felt compelled to do.

While admittedly the image of my father and I organizing spices invokes the clichéd trappings of Indian diaspora fiction, I am unexpectedly quieted by the memory of that afternoon. A week or so later, *The Lowland*, the latest novel by Jhumpa Lahiri (author of the Pulitzer Prize-winning *Interpreter of Maladies* and *The Namesake*) arrived at my door. Aware that it was partially set against the violence of the Naxalite student movement in Calcutta in the 1960s and '70s, which rippled from a peasant uprising in the small West Bengal village of Naxalbari, I felt an acute and long-abiding familiarity with the novel's premise.

My father was a gangly 18-year-old

"I just wanted to write a novel where there were no heroes necessarily," Lahiri says. "And in which no one is entirely innocent."

engineering student at Calcutta's Jadavpur University when he became deeply involved with the radical Maoist movement. A year later, in 1969, he was forced underground—most of his Naxalite friends were killed, jailed, or tortured in jail and killed. In December of 1973, he left Calcutta to complete his engineering degree at Washington University in St. Louis, finally finding his way to Montreal with a suitcase packed with LPs and not much else.

Since childhood I have shared a tacit camaraderie with my father, fathoming his past at a vague, heedful distance. Later, as a teenager, I began to understand more carefully the Naxalite history and my father's revolutionary roots as we chatted from the car to the grocery store and then back to the car while he ran weekend errands. I dissociated my father's tumultuous years at Jadavpur from his thumbing open a plastic produce bag or collecting bok choy from the local co-op. Since reading *The Lowland*, though, my perception has shifted and my father's past is less formless. He lived more years before becoming a parent than he has since, and those earlier years are the ones that have preoccupied me in recent months.

Shortlisted for the Man Booker Prize, *The Lowland* tells the ambitious 50-year story of one family bound by tragedy. It

begins with brothers, Subhash and Udayan, who were born 15 months apart but whose lives fork irrevocably when Subhash pursues a Ph.D. in Rhode Island and Udayan, after immersing himself in the Naxalite movement's violent actions against the state, is brutally shot and killed by the police. As Lahiri writes, in her plain yet truly perceptive way, Subhash was from this point forward an only son, "an experience that had left no impression in the first fifteen months of his life. That was to begin in earnest now."

Udayan is also survived by his young wife, Gauri, who—while he never learned of it—is pregnant with their daughter. Subhash, charged with a sense of fraternal obligation to his brother and awake to the struggles she will face alone in Calcutta, marries Gauri and brings her to the United States. Soon Bela is born, and while her parents have arranged themselves as a family, they live instead as a repercussion. Though Subhash cares for Bela as if he were her biological father, Bela's inevitable discovery of Udayan looms perilously for the majority of the novel.

Meanwhile, Gauri is maternally detached—"the love she'd once felt for Udayan refused to reconstitute itself"— and in seeking her own academic pursuits, makes a potentially unforgivable decision later in the book. Her story is *The Lowland*'s most poignant because from the moment we meet her, Gauri is occupied by Udayan. Once he is gone she tries desperately to reclaim herself. Theirs was Gauri's first love—the one that is meant to meander (and maybe break) but more so, move past that feverish sense of emotionally tenancy. "He was flirting with her. She felt him forming an opinion even as he stood there looking at her and talking to her. An aspect of her, in his mind, that he already possessed. He'd plucked it from her without her permission."

Grief is portrayed generationally, and is not only a result of *someone* lost but also *something* lost: a movement, a first love, a father who would never meet his granddaughter, a mother's now rheumy, detached stare. Long before all of that, two brothers were still boys pocketing golf balls at the Tolly Club, lacing their fingers together and lifting each other up over walls.

The Lowland, revisiting those themes of first-generation Indian immigrant life typically associated with Lahiri's writing, shifts between Calcutta's insurrection and the winding estuaries and quiet seaside beaches of Rhode Island, occasionally manufacturing local as metaphor: "On cloudy days, at intervals, the sound of a foghorn pierced the air, as conch shells were blown in Calcutta, to ward away evil." But the novel's most powerful juxtaposition is made between time periods as well as points of view. Jumping back and forth, the narrative seamlessly reconciles various family members' speckled remembrances and in this way, *The Lowland* does not belong to a single character. "I just wanted to write a novel where there were no heroes necessarily," Lahiri recently told me over the phone. "And in which no one is entirely innocent."

Occasionally my father will mention that he misses his parents. He'll say it in passing and sometimes out of context, as if it were a thought he had perhaps not meant to say aloud. Though my brother and I never met our grandfather, my father has recounted (and repeated) stories about him to us, occasionally pausing to say, *He would have really enjoyed you*. (I

am hard-pressed to find a more accurate description of a grandparent's love than the pleasure of a grandchild's very being.) In a sense, I am safeguarding the memories of my father's memories, or at least, a fictional account of them. They exist in the part of my recall that looks like a room washed in afternoon sunlight, brightening and darkening, and turning warm again as clouds pass.

Stories from my father's Naxalite years have been stored in a similarly illusory manner. And in talking with Lahiri, I learned that the history in *The Lowland*—inspired by a story that was told to her involving two brothers killed during a paramilitary raid in Tollygunge—is culled from a "blurry," dreamlike place in her memory. "I had grown up hearing stories about North Calcutta where my mother is from, stories about what was happening there, on the streets, the curfews and the shootouts. And it was all so foreign from my own upbringing. I didn't know how to approach it because I had had such an incredibly sheltered upbringing in comparison. Having absorbed this history as a young child living in the United States there was a complete sense of unreality of it."

That sense of disconnect is an essential trait of being first-generation. The "unreality" of one's earliest memories of a parent's memory accumulate like filmy residue. I am a culmination not just of my parents, but also of the space that removes me from their pasts. It is braided into my DNA, though I couldn't say exactly what *it* is. As Lahiri said of Bela, "She is who she is. She's struggling intensely with her identity but she doesn't even realize it."

Proof is *The Lowland*'s ballast. "Part of the history of what happened in those years in Calcutta was an attempt to leave no proof," Lahiri explained to me. "People were executed in cold blood. People were arrested beyond the law." *The Lowland*'s most striking imagery characterizes this idea. After Udayan dies, Gauri closes the door and shutters of their bedroom as if to safeguard any "invisible particles of him." Despite Bela's peripatetic life working on farms across the United States, physically she retains parts of her mother, like the "freckled constellation of [Gauri's] darker pigment, an almost solid patch at once contained and conspicuous." At the very start, Udayan's rascally childhood as the more boisterous of the two brothers is illustrated with an image of his footprints trailing down the family's cemented pathway—proof of his father's refusal (and incapacity) to pave over, to forget. "I think that when anything really traumatic happens in a family, it's very hard for any one member to really move on," Lahiri shared. "It alters the family fundamentally. They're all of a piece."

Over the last half decade my father has returned more regularly to Kolkata—in 2001 the city's name was changed to match its pronunciation in Bengali—sometimes visiting twice or three times in a year. With each stay he extends the length of his trip, renovating or further furnishing our apartment in Ballygunge Place. He reupholstered a loveseat with a ruddy orange striped fabric and the side tables have been re-stained a burnished mahogany. These are all, I have learned, pieces my father saved from his childhood home, that are recognizable to him in the way the curved back of a chair can, in a flash, conjure a parent's reading posture.

But there is also, among the testaments to another time, the incongruent

new. A year ago my father mounted a flatscreen TV onto the living room wall so he could watch cricket matches, and in January, when we all vacationed together in Kerala then Kolkata, I noticed little tokens of Montreal—as simple as dishtowels or a brand of shampoo—that he'd brought and left there. I drank tea every morning from a mug with a faded Sears portrait of my brother and I printed on one side. We're wearing matching T-shirts and haircuts, and emphatic, near goofy smiles.

Growing up in Montreal, our home was decorated with handloom cushion covers and block-printed tablecloths. In the linen closet, my mother stored extra bars of Sandalwood soap, the smell overpowering our towels and pillowcases. Now in Kolkata, the inverse was true. It felt as though my father was steadily moving toward his past, one travelled trinket at a time.

While I am careful to separate my interest in Lahiri's work from a self-involved enthusiasm about a Bengali woman writer who is also first generation and was raised on the East Coast, I cannot deny the delight (and innocence) of recognition—often brought on by a word or turn of phrase as basic as "Baba," that I had only ever heard at home but now find printed in the *The New Yorker* on my lap as I ride the subway. These are the naïve moments I allow myself because I have never once called my father "Dad."

But once I started reading *The Lowland*, recognition turned to pang and I no longer felt like an innocent reader. I have since realized how guiltlessly you can love a book when the emotional connection is strictly yours. What if the story is nearest to your parents' past? To that inaccessible nook of pain they've carried with them

That sense of disconnect is an essential trait of being first-generation. I am a culmination not just of my parents, but also of the space that removes me from their pasts. It is braided into my DNA, though I couldn't say exactly what *it* is.

through parenthood? Never before have I felt so plainly the inheritance of trauma.

The day my father flew back to Montreal after his New York trip, I emailed my friend the sort of thought I have an hour or so after I've said goodbye to someone I love, knowing well that he or she is still in the same city as me, likely only just past security at the airport. I wrote: *I wonder when my parents became parents first and everything else second.* Over the month that followed I would immerse myself in a novel set during a misplaced time I had only ever heard about at home, that was now on my lap as I rode the subway, as I reached into my bag to pull out my pen and underline sentences like, *It was the sort of spontaneous association one might make while looking up at a passing cloud*, as though nudging myself to text my father later, simply to say, *Hi!*

Originally from Montreal, Durga Chew-Bose is a writer living in Brooklyn. She has contributed to The New Inquiry, Flare, GQ.com, Hazlitt, *and* Interview Magazine *among others.*

"An equal to any ancient Greek or Chinese account of empires rising and falling ... A great, heartbreaking novel, full of fierce action and superb characters and an unblinking humanity."
—THE GLOBE AND MAIL

THE ORENDA — JOSEPH BOYDEN

CRITICALLY ACCLAIMED NEW NOVELS FROM TWO OF CANADA'S MOST BELOVED WRITERS

Read excerpts at HAMISHHAMILTON.CA/UPFRONTS

"A masterful examination of the very marrow of life ... MINISTER WITHOUT PORTFOLIO is essential reading, an honest, and at times frank-to-the-point-of-discomfort exploration of guilt, loss, faint hope and struggle." —NATIONAL POST

Michael Winter — MINISTER WITHOUT PORTFOLIO

Three Eulogies: Wendy O. Williams Valerie Solanas Cookie Mueller

Alexandra Molotkow

ART BY ADRIENNE KAMMERER

Alexandra Molotkow

WENDY O. WILLIAMS (1949–1998)

Wendy O. Williams killed herself 15 years ago this April. She left behind presents for her partner, Rod Swenson—noodles he liked, seeds for salad greens—and a few notes. "My feelings about what I am doing ring loud and clear to an inner ear and a place where there is no self, only calm," she wrote. Then she went out into the woods and shot herself.

Williams had met Swenson over 20 years earlier, when, having just arrived in New York, she applied for a job with Captain Kink's Sex Fantasy Theater (he was Captain Kink). They formed the Plasmatics, part punk-metal band, part art concept, and she was a spectacular frontwoman: a grunting, nearly naked force of id who could stand still in front of an audience or slice a guitar in half for them with a chainsaw. Her career lasted a decade. When it was over she accompanied Swenson to Storrs, Connecticut, where, as Joy Williams reported for *Spin*, in as careful an elegy as one could hope to receive, he built a geodesic dome for them to live in.

In Storrs, Williams volunteered at an animal shelter, nursed baby squirrels, and sold vitamins at a health shop. She was only biding time. Her life had settled into a permanent Sunday: it was all over except for the feeling that it was all over. In 1993, she stabbed herself in the chest; in 1997 she overdosed on ephedrine. She'd made up her mind, she insisted it was for the best, and, as Joy Williams writes, all Swenson could do was delay the inevitable—"She could create a future only by killing herself."

On October 5, 2007, the French writer Edouard Levé handed in the manuscript for a novel called *Suicide*. He hanged himself ten days later. The book is written in the second person, addressed to a friend who shot himself at 25, and it's a catalogue of a life: you can peruse it like a dictionary, "like picking marbles out of a bag," to mix two of Levé's metaphors. "You used to want only to perform acts that would resonate for a long time," he wrote, "gestures that, though completed in a few minutes, would leave vestiges to persist and continue to be seen."

A theme in *Suicide* is how the future changes the past. It would be nice to think that moments are relivable, that the best times of our lives are still happening in a dimension allowed by the laws of physics. But we know that memories are just memories of memories: they lose their connection to the moments that spawned them, they have more to do with how you are now than the way you were then.

I like to think that moments are less important than memories—that when the best is over we're left with something better, a fantasy our minds could animate for us as we ride out to brain death. Sadly, memories can

rot, and maybe that's worse than death. The present is a spine that orders the past and the future; when it shifts, everything does. Suicide is a way of preserving the past you'd like to have lived.

Since art is more consistent than recall, it makes sense to preserve your memories—as well as those dreamlike feelings they produce as they decompose—by investing them in work. "When you recalled it, it was made weaker by your memory's many points of imprecision. But others had imagined life in books: what you were reading was the superimposition of two consciousnesses, yours and that of the author. You used to doubt what you had perceived, but never what others invented." Levé wrote this in a book, and then he killed himself.

If your work is done, why stick around? Particularly if your work is living a certain way, which, for Williams, it seems to have been; particularly if you think of your work as your afterlife, which Levé might have. If there's nothing after death, it makes sense to want to end at the right place. "In art, to reduce is perfect," Levé wrote. "Your disappearance bestowed a negative beauty on you." To keep living would be to add stupid adverbs or unnecessary scat verses. It might ruin the whole thing.

There's death as the end of living and there's death as the end of life. The difference is similar to that between missing somebody and grieving them. Death as the end of living is melancholy; it's beautiful to imagine. Death as the end of life is the worst thing you can imagine. The former makes sense of suicide and the latter makes it inconceivable. I'd prefer to think about death as the last dotted "i," but who knows what one thinks in their final moments.

VALERIE SOLANAS (1936–1988)

It's too bad that Valerie Solanas shot Andy Warhol, because *SCUM Manifesto*, the radical feminist pamphlet she wrote in 1967, is a great piece of literature: a lucid and very funny expression of feelings that most of us have but know better than to accept as beliefs. By "most of us," I don't only mean women (SCUM stands for Society for Cutting Up Men). On the surface the manifesto is a screed against males, but more generally it's a screed against Everything Wrong With the World. You can choose your own enemy.

Solanas, as you might know, seems to have lacked the capacity to distinguish between feelings and reasonable beliefs: she lived in that moment where the guy next to you on the bus sneezes without covering

his mouth and you hope he gets bisected by a falling window. I think a dozen horrible thoughts just getting to the office, but when I step off the streetcar, I'm back in society. Solanas was never in society, which is probably why she was such a good social satirist, whether or not she intended to be.

If you can ignore the fact that Solanas tried to murder three people on June 3, 1968 (Warhol, whom she shot through multiple organs; the art critic and curator Mario Amaya, whom she shot near the hip; and Warhol's manager, Fred Hughes, whom she'd have shot in the head had the gun not jammed), you might find her work exhilarating. As the monologue of an angry brain, without a social chip to pipe in with *Shush, that's terrible*, the essay is clear and abides a logic—most of her points are valid, if deeply unsound—and it galvanizes the way a Nine Inch Nails song does. (To my knowledge, no Nine Inch Nails song advocates for the extermination of males, though there might be a Swans song to that effect.)

Solanas had excellent brain-gut synergy; and she had a conscience, albeit one dangerously out of tune with the real world. "I consider [the shooting] a moral act," she told the *Village Voice* in 1977. "And I consider it immoral that I missed."

Solanas didn't shoot Warhol because he was male. She shot him at least partly because she believed he was conspiring with her editor, Maurice Girodias of Olympia Press, to steal her work; she is said to have been diagnosed with schizophrenia. But she did hate men, purely and truly, and from accounts of her life (including one by Freddie Baer, published with the manifesto) she had reason to. Her father sexually abused her, and after her mother remarried, her grandfather beat her. By age 15 she was on her own; she finished school regardless, and attended the University of Maryland at College Park for psychology.

There, she worked as a research assistant for Dr. Robert Brush, whom Mary Harron, director of *I Shot Andy Warhol*, tracked down with the help of researcher Diane Tucker. "I had a warm spot for her," he said. "I felt she'd come up the hard way." She put herself through college by way of sex work, and when she landed in Greenwich Village in the mid-'60s, she made money by panhandling, turning tricks, and, as Harron writes, selling her conversation to passersby for six bucks an hour. ("The male's 'conversation,' when not about himself, is an impersonal droning on, removed from anything of human value," she later wrote.) She completed a play called *Up Your Ass* and gave it to Warhol, who lost it; and the *SCUM Manifesto*, which she peddled on the street.

The contempt, and the disgust, and the homicidal fervour are very real, but her grievances are often relatable, taken with a grain of salt, and she writes what plenty of women have felt, if not necessarily believed. In her view, males are responsible for war, disease, fear, conformity, authority, and work (everything would be automated by now if men didn't need projects to justify their existence). Everything a rebel rebels against, in other words. But you can substitute "male" for whoever your beef is with—rich people, lizards in human disguises—and if you could substitute "maleness" for a more abstract quality, something you couldn't pin on any one type of person and then set out to destroy them for, you'd have a pretty righteous philosophical tract.

Solanas, for her part, thought philosophy was a farce: Men, being empty and incapable of empathy, have to "label the male condition the Human Condition" and "post their nothingness problem . . . as a philosophical dilemma." A woman, however, "knows instinctively that the only wrong is to hurt others, and that the meaning of life is love."

Shining under the bile is insight. Harron wrote that Solanas wasn't very interested in art, which is strange because *SCUM*'s endpoint is creative utopia: "In actual fact the female function is to explore, discover, invent, solve problems, crack jokes, make music—all with love. In other words, create a magic world." Men (or the bourgeoisie, or kids these days) "[have] no deep-seated individuality, which stems from what intrigues you, what outside yourself absorbs you, what you're in relation to," and that's a great rule of thumb. Solanas believed that Western philosophy only plants flags in the true and obvious, that "Great Art" passes off obscurity for depth. I get it.

Ignore the madness, and the bigotry (Solanas had some nasty things to say about gay men and trans people), and you realize the *SCUM Manifesto* is really funny. In a ranty, cathartic way that makes me wish she had done standup, as well as in a more elegant, Swiftian sense—although Swift, now that I think of it, was quite ranty, and the *SCUM Manifesto* is funnier than *A Modest Proposal*. For men sympathetic to her objectives (that is, men who accept their inferiority), she prescribes "Turd Sessions, at which every male present will give a speech beginning with the sentence: 'I am a turd, a lowly abject turd,' then proceed to list all the ways in which he is. His reward for doing so will be the opportunity to fraternize after the session for a whole, solid hour with the SCUM who will be present." Among the most harmful men are those "who sit idly on the street and mar the landscape with their presence."

Solanas rants about women, too. Privileged, middle-class "Daddy's

Girls" are so brainwashed "that they try to groove on labour pains and lie around in the most advanced nation in the world in the middle of the twentieth century with babies chomping away on their tits." I'm not sure what a SCUM woman does all day, exactly, besides writing manifestos and mauling Great Artists. Because at the end of the day, SCUM was just Solanas. "Man" was everyone else.

After shooting Warhol and Amaya, Solanas handed her gun to a cop in Times Square. She pleaded guilty to reckless assault with intent to harm, and received a three-year sentence; a couple of months later, Olympia Press published the *SCUM Manifesto*. Shortly after her release, Baer writes, Solanas was arrested for making threats to Warhol and others. In 1977, she contacted a columnist at the *Village Voice*, asking him to write about a new, self-published edition of the manifesto. She said, of *SCUM* itself, "It's just a literary device . . . It's either nothing or it's just me, depending on how you define it. I mean, I thought of it as a state of mind." The interviewer asked if her views had changed. Solanas said, "No."

As far as anyone knows, Solanas spent the last decade of her life in New York and California, presumably bouncing around crash pads. "She was writing," her mother told an interviewer for *New York Magazine*. "She fancied herself a writer, and I think she did have some talent," as well as a "terrific sense of humour." Twenty-five years ago, her body was found kneeling by the bed of a single-room occupancy unit in San Francisco's Tenderloin District, where, Harron says, she'd been spotted typing away at a desk next to a stack of papers. According to the police report, "Her body was covered in maggots and the room appeared orderly."

COOKIE MUELLER (1949–1989)
"Perhaps there is no hope left for the whole of humankind," wrote Cookie Mueller, "not because of the nature of the epidemic, but the nature of those it strikes." Cookie first learned about AIDS in July 1981, from a *New York Times* item she'd read aloud to friends on Fire Island. By early 1989, having lost who knows how many friends, she saw her husband, the artist Vittorio Scarpati, hospitalized with two collapsed lungs. "I hope he comes home soon," she wrote in her art column for *Details* magazine, but he died in September. Nan Goldin, a close friend, photographed Cookie at his funeral and, several weeks later, in her casket.

Goldin put together a portfolio of photographs of Cookie from 1976 to 1989. "I used to think I couldn't lose anyone if I photographed them

enough," she wrote in the accompanying text. It wasn't true, of course: Goldin lost Cookie the friend, mother, and person. But Cookie Mueller, the character, isn't lost: She's there in Goldin's photographs, the films of John Waters, and the stories she wrote about her own life, a life I can't imagine her regretting even as it ended too soon.

Cookie Mueller was born in March 1949. At 15, she teased her hair until it scraped the ceiling and clomped down the halls of her Baltimore high school in spike heels and cone bras. She dated a boy who was in and out of jail and a girl "born of a lightbulb it seemed," whose "scalp shone through all the teasing as if her head was a mango." She arrived in Haight-Ashbury just in time for the Summer of Love, where she encountered Janis Joplin, Jimi Hendrix, and Anton LaVey (from her account), and munched acid until her roommates had her institutionalized. After being transferred to a hospital in Maryland, she met John Waters at the premiere for his *Mondo Trasho*, and would appear in five of his movies: dancing topless to "Jail House Rock" in *Multiple Maniacs*; brandishing a flogger in *Desperate Living*; getting screwed with a chicken in *Pink Flamingos*.

From the freak wharfs of Baltimore (where she lived, according to her writings, in a crowded three-room basement with a cockroach-eating pet monkey) and Provincetown (where a friend, interviewed for a short documentary, remembers her donning a monkey fur coat to pick up the welfare cheque), she travelled the world with her young son, Max, landing in Lower Manhattan where she became, in Goldin's words, "sort of the queen of the whole downtown social scene." She wrote a medical advice column for the *East Village Eye*—a "'health in the face of drug use' column," as she called it—and the art review for *Details*; she go-go danced and, according to a commenter on *Motherboards NYC*, sold MDA, which customers would refer to as "a Master's Degree in Art."

John Waters remembered her snorting instant coffee "because she 'didn't have time' to make it the normal way." She claimed that every morning, no matter how bad the hangover, she hoisted herself out of bed to get Max ready for school.

Cookie Mueller had her own normal and her own values—good values, adapted for a life that careened like a unicycle down a fire escape. She was the kind of person who seems to live adjacent to the rest of us, subject to different rules and different laws of cause and effect. Adventures just accrued to her, like money or lovers for some ("I'm not wild," she wrote, "I happen to stumble onto wildness. It gets in my path"). And she was lucky, in her way: in Sicily, she rented a car, totalled the roof, then

returned it to an inspector too short to notice the damage; in Elkton, Maryland, she was kidnapped by gun-wielding hillbillies and escaped by hiding in the woods under the lining of her black velvet jacket. She lived a short life as a born survivor; you picture her losing an arm, then tossing it into the icebox as she fishes out a beer.

Mueller recorded her life, in her columns and in short, mostly autobiographical stories collected in the wonderfully titled *Walking Through Clear Water in a Pool Painted Black*, which is still in print, and the more extensive *Ask Dr. Mueller*, which is worth the price on AbeBooks. She was a good writer, with excellent stories to tell but also chops: she pictured John Waters as a "tiny baby, fully developed and compact like a pound cake, almost bursting his bunting wrapper with the desire to communicate to anybody who'd listen," which is a good description of her tales; the New York summer heat is "served as thick as lava gravy" and "closing in like the lid of a waffle iron." Her characterizations are precise and brimming. She lived in a different world with the same mud puddles.

It's tempting to think of Cookie Mueller as a doer first and a writer second, because it's comforting, when you write and you're dull, to think of dullness as the writer's lot. The wild are not supposed to have insight, which is reserved for those of us too mired in our own heads to participate. The funny are not supposed to be beautiful, the beautiful are not supposed to be smart—either/ors as bulkheads for our frail senses of self. This is stupid. Some people make beautiful work and some people live rich lives, and some people make beautiful work about their rich lives. The same genius that makes a story can make a life.

From where I sit, it's better to record than to be recorded. Moments pass and when you're gone so is everything you ever lived through; your world ends, even if you are remembered, and what good is it to live forever, estranged? It seems better to leave a semblance of your world than to live as just a character in someone else's. Best, though, to have both.

Cookie Mueller died at 40, under tragic circumstances in tragic times, but she lived an extraordinary life very quickly—she had a skill for living extraordinarily, and an equal skill for self-expression. Cookie was a character: for John Waters, for Nan Goldin. But she was a character with the genius to write her world, and that's another way she was lucky.

Alexandra Molotkow is a Senior Editor at Hazlitt.

Xavier Dolan's Great Expectations

Calum Marsh

The Quebecois director talks about his latest film, *Tom at the Farm*, how his work is received in America, and why he never gets around to actually watching movies.

From Orson Welles and George Lucas to Martin Scorsese, cinema has a long tradition of encouraging and enabling precocity. Yet even among the pantheon of notoriously vernal auteurs, French-Canadian actor, writer, and director Xavier Dolan is an extraordinary case. At 24, he is no longer the youngest filmmaker on the festival circuit. But how many directors at that age have matured as quickly and embraced such a variety of styles and themes? *Tom at the Farm* is already Dolan's fourth feature film, and if it's not quite his best—to my mind that honour remains with his previous effort, the sprawling transgender epic *Laurence Anyways*—it is nevertheless his most sophisticated and assured, the work of an artist fully in command of his craft.

Hazlitt sat down with Dolan before the North American premiere of *Tom at the Farm* at the 2013 Toronto International Film Festival. Dolan has developed a reputation for being occasionally confrontational with the media, and though our chat was more than pleasant, he couldn't resist beginning with a point of possible contention.

Xavier Dolan: You hated it.

The film? No, not at all. I liked it very much.

I'd be afraid to read your review if you hated it.

I don't think I'll be writing about it until it gets released in the States, either way.

So in five years.

That's what I assumed. Somebody asked me if it was going to be released in the US soon, and I told them not to expect it until probably 2015, as usual.

To be honest, no, not this time. We're looking to secure distribution now, which is good. It's been ground zero for me in the States, what with *Laurence Anyways* performing so badly this year. Nobody in America knows who I am.

The films have been critically well-received, though.

They've been well-received, sure, but the motivation for making movies is that people actually see them. I mean, *Laurence* was very warmly received by American critics. I read all the reviews, including the negative ones, and it's been very inspiring to read such fine pieces of criticism. I've not seen this anywhere else in American criticism. I've never seen such a thorough analysis of a movie from people who don't even like the film in some cases. People were working through the social implications, and about what the film has to say. I was flattered that people would take the time to think about the movie even if they don't care for it.

I think your films have a certain richness that's obvious even if people don't particularly respond to them. They are hard to dismiss. How do you think people will respond to this film?

People tell me the movie is going to be divisive, but I have no idea why. It's a classic thriller. This screenplay is Syd Field-approved—it couldn't be more classical. There was no place for ego or for visual liberties. First of all, I had no time—we shot this in 17 days. We had no money. What could I do? And then I stumbled upon the making-of documentary on the DVD for Sidney Lumet's *12 Angry Men*. Obviously that small, confined space where the film is set [a sequestered jury] meant there were all kinds of limitations, but they found ways of showing a progression visually, conveying how it would all unravel just through the use of close-ups and framing. And so I decided to do the same kind of thing, increasing the use of the close-up as the film goes on. The only

Calum Marsh

other trick I used was to change the aspect ratio during certain sequences.

And what was the significance of that for you?

It sounds stupid to describe it. What do you think it was?

Obviously it comes at moments when the characters feel trapped, so I suppose it reflects that feeling.

Yes. But you know, I think it's okay to be banal sometimes. Some things just work. If you feel they do, keep them.

I think some things that sound obvious when described have a certain elegance when conveyed visually.

And the movie isn't exactly showing off in those moments, either. There's no cerebral intent, it's just a matter of having fun. We're trying to play with the grammar a little. The film is purged of my usual stylistic tics, because there was no place for anything like that. I mean, could the movie bear a slow-motion sequence in the fields, set to a Swedish pop song? Actually... that would kind of be great, but it wouldn't be the same movie.

It's a lean film, especially compared to your earlier work. And yet there's a very palpable atmosphere at play.

It was pretty much decided beforehand how the movie would feel and how it would look. I wanted a no-look film. Which is not really how it turned out in post-production when we started to get excited with colour timing. But when we shot the film, it was meant to clearly look like the bland 2000s—not the '80s, not the future, but just the 2000s. There's nothing more impressive than that because it's populated by these no-name decorations, and all of this no-name clothing.

It's a world of blonde wood. It's so depressing. There's no style. I didn't want to have the *Days of Heaven* barn. We're not gonna shoot at the magic hour. I wanted it to look ugly and real. And it can be a little cerebral to start thinking about that, because then you're talking about the aesthetic of ugliness, I guess. But I restrained myself in every possible way. For example, it's very trendy right now to shoot with very little depth of field, but I insisted against it—I didn't want that creamy blur. I just wanted it to be ugly. I wanted it to be weird. I wanted it to be tense and scary.

Like horror?

It's not a horror movie exactly, but obviously at some point you're going to be wondering what's happening and you have to fear for the character's life, or else I've failed dramatically.

Well, I found it tense and scary—not only because you fear for the character, but because you fear where the film is taking you.

The question should be: who is going to die? I'd never seen any Hitchcock movies when I went to make this movie.

You're kidding.

No! Everybody compares the movie to Hitchcock, but I'd never seen any of his stuff. I've never seen so many important movies. My culture is just so fucking stranded. Everybody is under the impression that I've seen so many movies. I started watching serious movies when I was 16, and went on until I was 18, and then I started making movies 24/7, one movie a year. When could I possibly watch movies? I've seen many movies from the '90s, or when I was a kid. And I do go to the movies now. I keep compulsively buying movies, from like drug stores or gas stations

on highways, but I don't watch them. I have this massive collection now, but it's all so phony. The point is, it's possible for me to make this movie without having seen any Hitchcock, the same way I've not seen any Tarkovsky, or any Fassbinder...

And you get Fassbinder comparisons a lot.

I get compared to Fassbinder all the time, though hopefully without the cocaine addiction and the weight.

What about Godard?

I've seen maybe two Godard films and I really don't like them.

I thought maybe Gabriel Yared, the composer you worked with on *Tom at the Farm*, was chosen because he worked with Godard on *Sauve Qui Peut (La Vie)*.

But he also did *The Talented Mr. Ripley* and the *The Lives of Others*, and a million other things. What I liked about him is that he's not a score guy, he's a composer. His music is insane. The trajectory of his reasoning is so extravagant. You'll tell him, "That's a very audacious African instrument that hasn't been used in 20 years, are you sure you want to use it?" And he'll say, "Oh, what instrument?" Sonically, it's very impressive to me. When I heard the score, I thought, *Wow, it's a real score.*

This is the first film you haven't loaded with pop songs.

You don't want to just play by your own rules, as if you have a signature. I want to look at a script and ask what it needs, and *Tom* needed severity. I saw the blonde hair and the blonde fields, and a kind of feral or masculine look to the landscape, even though the film is sort of queer. Though for me, it's not actually a "queer film." I hate when people say that. I think it intends to be a sort of psychosexual thriller, but it's more about the violence we feel and the intolerance, more than simply homophobia. It's not homophobia so much as the loneliness we feel in the city or the country, and the way we live it out or express it. It's about how we bridge that ever-growing gap between city and town.

Is the film trying to articulate something about rural life? Perhaps something negative?

For me it's about such a specific family, and such a specific and isolated case of insanity. I was brought up in the country, on a beach. And then in the Montreal suburbs. I do not have an opinion on people from the farm. I'm not a fucking townie saying, "Oh, people will hurt you out there!" I'm not a Rufus Wainwright song, is what I'm saying. Intolerance is everywhere. You can get the shit beaten out of you in broad daylight in Montreal, and we're a pretty goddamn tolerant city. It's not a take on the urban/rural thing in that way. There's a lot of loneliness. The loneliness you'll find in the city and the country have a lot of similarities, and they collide in *Tom*. It's not a movie on homophobia and it's not a movie on the fact that whenever you step out of town you'll find homophobia or intolerance. The play it's based on is about this character going to a specific farm, not "the farm" as a stand-in for all farms. I know people will see it that way. They'll think it's prejudiced or contemptuous, but you know what? I really don't give a shit.

Calum Marsh is a freelance film critic and essayist living in Toronto. His writings have appeared in Hazlitt, Esquire, the Village Voice, *and* Sight & Sound.

Touching the Dead: Spooky Winnipeg

Tom Jokinen

Once the transportation hub of Canada, Winnipeg was also a nerve centre of psychic investigations thanks to the work of Dr. Thomas Glendenning Hamilton in the early 20th century. And today, with more funeral homes than Starbucks, it remains a world capital of creepy.

It's no great trick to touch the dead. What you need is the right apparatus, which is the logic behind the séance: the medium can read signals in what is, to the rest of us, garble. She tunes them in like a radio, to use a concept dreamed up by British author and artist Tom McCarthy. It's simple physics: the total energy in an isolated system remains constant over time, so the dead leave a revenant (heat, magnetic energy, something electrical) that can, in theory, be measured. Energy doesn't disappear but is converted, and if the theory holds, we expect it can be un-converted through some "software" (Madame Whoozitz and her crystal ball) that operates by

spooky algorithm. That's fun, or unsettling, depending on your faith and emotional wiring.

My guess is that it's not easy, or we'd all be haunted all the time: while shaving or opening a can of soup. Some places, no doubt, are more receptive than others. On the prairie you can hear radio stations from Texas bounced off the ionosphere. Maybe that's why prairie towns are more haunted by those other signals than, say, Toronto or Montreal, where there's too much static. I think Winnipeg is a particularly strong receiver.

On Halloween in Winnipeg, kids dress in orange and poppy-red and *Scream* masks, and then cover it all up with winter coats. They work the more fertile neighbourhoods of River Heights and Wolseley like gleaners in a wheat field, harvesting candy: sure, it's fun, but there seem to be heavier presentiments in play as well. Grown-ups hand out Tootsie Rolls in acts of ritual appeasement. Owls fly low in cemeteries and at Oak Hammock Marsh, a nature preserve north of the city that hosts pumpkin carvings, as close as you can get to pagan sacrifice. Halloween is a kind of secular Passover: follow the protocols, hope for the best, spirits move on.

I'm not from Winnipeg but spent five winters there, long enough to feel a particular brand of death-awareness: there are more funeral homes in Winnipeg than Starbucks. In 1998 there was trouble at the Elmwood Cemetery. Bank erosion exposed a stretch of property and threatened to send caskets sliding into the Red River: 108 graves had to be moved. This was discussed in town, I'm told, not as an infrastructure problem but as folklore: that was the year they wouldn't stay buried. W.G. Sebald wrote in *The Emigrants*, "And so they are ever returning to us, the dead," a reference to 20th-century Euro-

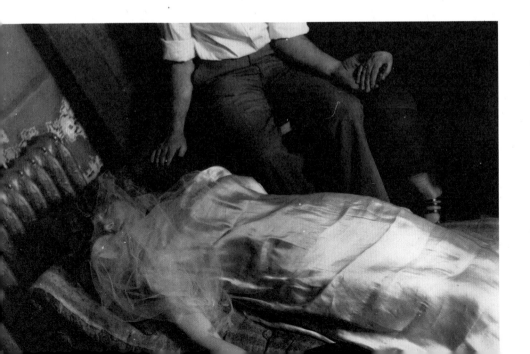

pean history and the Freudian return of the repressed. It is a suitable motto for Winnipeg.

The city used to be a transportation hub, Chicago of the north, and then trading lines and commercial preferences changed, leaving behind a rusty ribbon of neglected railway lines: a ghost of global capitalism. Appropriately, Winnipeg was also a hub for psychic activity in the early 1900s, thanks to the work of Thomas Glendenning Hamilton, a surgeon, school trustee, Liberal member of the Manitoba Legislature, and séance impresario. In 1919, after one of his twin sons died, Hamilton began to experiment with Ouija boards and table-tipping, the well-known method of decoding messages from the dead through the kitchen furniture: one called out letters of the alphabet, and when the table tipped, one moved on to the next letter until sentences were revealed. His Scottish nanny, Mrs. Poole, turned out to be a skilled table-tipper.

Investigations (and gatherings of the curious) were held in a second-floor study at his home. There was no shame in it: psychic gatherings were as common in the industrial west (and as social) as scotch nosings. The famous travelled the world to see firsthand how the dead had learned to communicate with the living, or vice versa. Sir Arthur Conan Doyle, author of the Sherlock Holmes books, came to Winnipeg in 1923 and after a press conference at the Fort Garry Hotel, dropped in on Glendenning Hamilton, joined one of his salons. Conan Doyle met Mrs. Poole, whom he described as a "small, pleasant-faced woman from the Western Highlands." He sat at a table, lit by phosphorous, with nine others, including his wife. The table, he said later, commenced to clattering "like a restless dog in a kennel, springing, tossing, beating up against supports, and finally bounding out with a velocity which caused me to quickly get out of the way." In his 1924 book, *Our Second American Adventure*, Doyle would write:

> "I came away with the conclusion that Winnipeg stands very high among the places we have visited for its psychic possibilities."

As a skeptic and scientist, Hamilton was quick to see the opportunity for research in the activities of the second floor. He fitted the room with a dozen cameras, shutters open. The room was lit with a single red bulb so as not to expose the film. During the séance, if the table should tip or if Mrs. Poole should launch into a trance (by this time she was known to the psychic community as "Elizabeth M"), Hamilton would trigger a flash with an electronic device. He produced scores of glass plates, shockingly candid moments of the action. The pictures and reams of documentation on "rappings, clairvoyance, trance states and trance charts, telekinesis, wax molds [of fingertips], bell-ringing, transcripts and visions as well as teleplasmic manifestations" are still stored at the University of Manitoba, available for study. The latter are the most curious: the "teleplasmic manifestation," or the egestion of ectoplasm, was the Grand Slam Home Run of any proper séance. The medium, in a trance, would seem to spit out some otherworldly goop in which could be seen the faces of the dead. Glendenning Hamilton had the pictures to prove it. Filmmaker Guy Maddin, no surprise, is a student of the Hamilton

Tom Jokinen

archive: the glass-plate ectoplasm pictures turn up in his film *My Winnipeg*, and an installation he created for the Winnipeg Art Gallery featured pyjama-clad teenage girls holding a séance in a mock-up of his boyhood bedroom. The Hamilton pictures are all over the internet, which itself is brimming with encrypted signals: how many long-dead faces do you encounter every day just browsing the web?

In the 1920s, Winnipeg was known as the "ectoplasm capital of the world." Consider the context: after the Great War, 16 million killed worldwide. The afterlife, if there was one, was suddenly stuffed with the souls of those taken suddenly and prematurely. At the same time: the West had become, if not more secular, then more confounded, and enthralled, by the possibilities of science, which could fathom wireless transmission. In 1926, John Logie Baird, a Scottish engineer, introduced the first television. Images and sound could be conjured from the air, not as superstitious twaddle but as electricity, real and measurable. You could believe in the stuff based on empirical proof, whereas religion, the only other conduit to the other world, still called for faith: belief without proof. Consider the allure of the former, when locked in grief.

Of course, it's the great question: if there is an afterlife, Christian or Zoroastrian or whatever, why wouldn't a God make it manifest, available for inspection, to cut out the mystery of faith and move instant-whammo straight to belief? Dostoevsky played this game with rigorous and disturbing rhetorical clarity in *The Brothers Karamazov*, with the story of "The Grand Inquisitor." Christ returns to Earth at the time of the Inquisition and is challenged by the Inquisitor on just this point: when Satan tempted you with an opportunity to show yourself, to turn stone into bread and prove your divinity, why didn't you take it? Instead you leave man with the heavy burden of free choice: no proof, just faith, or not. The Inquisitor is a rational man, who has no choice now but to enforce belief through terror and violence: burning heretics. The dignity of freedom is too much for man; better the slavery of knowing for sure.

Not that Dostoevsky was picking on spiritualists (he was in fact picking on the dogma of the Roman Church), but the point applies: is knowledge of life after death liberating, or does it lock you into some horrible box? Here's your eternity: millennia of tipping over other people's tables at parties. Easier to think of death just as another measurable quantity, like the movement of planets or energy in a closed system, and, presumably, plenty of Hamilton's séance guests saw it this way. Grief helps tip the balance, too. People just wanted to know that their sons were safe.

It matters that Hamilton found spiritualism after his son died. As Tom McCarthy points out, Alexander Graham Bell had made a pact with his brother: if one of them died, the other would invent a device capable of receiving messages from the dead. The brother died. Bell invented the telephone. McCarthy is mad for ghostly communications and codes begging to be cracked. In his art, he plays at the idea of repetitive radio messages from the underworld, like the cryptic threads of poetry in Jean Cocteau's film *Orphée*: radio that can only be heard by tuning between the stations. The hero

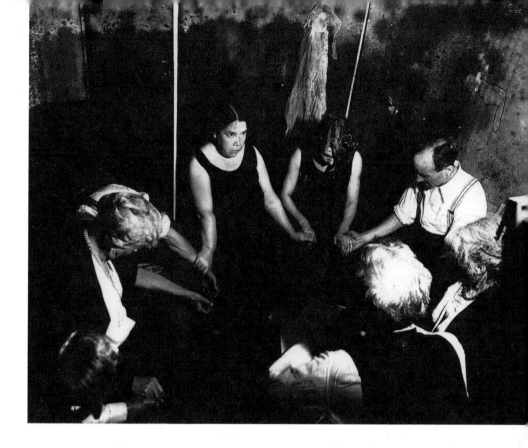

of McCarthy's Booker-nominated novel *C* is a heroin-addicted wireless operator in the Great War, who winds up at a séance only to reveal it as a sham: the hoaxers used radio-controlled gizmos to make the tables tip. Underneath it all is a whopping dollop of French Theory: the closer you look the less you see, or the closer you look the quicker you uncover the lie. McCarthy says we live in a frantic mess of signals, but we decide how to decode them. Hoax or miracle? It's up to you. If you want to hear the dead in the white noise, to know they are safe and playing chess with Napoleon, that's what you'll hear: grief is a sharp tuning instrument.

What was the lie in Glendenning Hamilton's work? Study the pictures. Or just click through them, same outcome. Chilling, in some cases beautiful (the 1934 picture of a woman named Mary M., back arched on a couch, looks like a Henry James character who's fallen into an F.W. Murnau film), they're full of holes: the ectoplasm pouring from poor Mrs. Poole's mouth and nose is either gauze bandaging or crumpled tissue paper in which cut-out photos of faces have been glued. Those skilled in spotting cheeseball Photoshop effects need not even break a sweat. In one case you can see the smiling face of Arthur Conan Doyle, who, the story goes, returned to Winnipeg in 1931, the year after he died, coming out of Mrs. Poole's nose.

Who's the hoaxer? In Dostoevsky fashion, we're not meant to know. Enough that Glendenning Hamilton, one-time head of the Canadian Medical Association, made this his life's work after his son died.

Tom Jokinen lives in Ottawa.

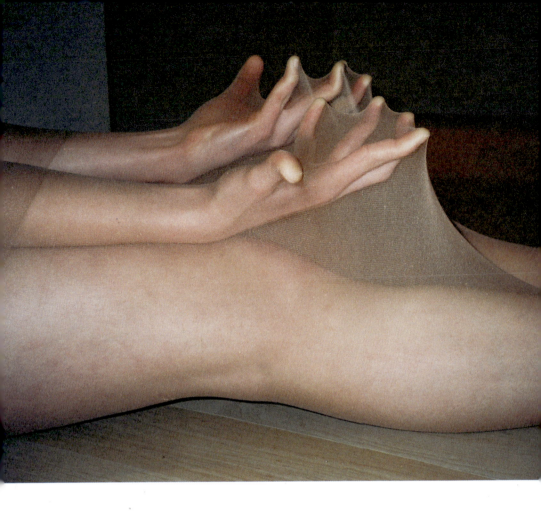

Second Tongue

Jowita Bydlowska

At the age of fifteen, knowing hardly a word of English, she comes to Canada from Poland. This is how it was: two different languages, two different lives.

PHOTOGRAPHY BY KRISTIE MULLER

There was a plane crash—that's the kind of line I'd like to open this with but there was no plane crash, just me wishing there would be one. I was going to a country with no words. Or the words were there but I didn't know them. Without words, it was as if I was getting born. Except I had already been alive for fifteen years. I wanted to die.

We landed in Toronto, lined up with other grey-faced newcomers (*Welcome to Canada*, the signs read), got our lives stamped under bile-green lights, moved forward, got spat out of sliding doors right at my father waiting behind the red rope. Then we drove along an endless slab of asphalt—the sea-wide highways—in my father's Buick. Then we were here: Hiawatha Street. Hiawatha, I repeated and repeated, testing, tasting the rhythm of the new word.

Our apartment was white and clean. There was a plastic patio set in my parents' bedroom/living/dining room. A hole in the middle of the table. No umbrella. My sister and I shared a room, the beds without mattresses, just the box spring. Exhausted, our skin humming from the flight, we slept hard. That week, my father lost his good job. He was now powdering donuts at night at Tim Hortons.

From the start, the family was tense about being here. Grieving wordlessly—even though we spoke the same language. Someone was due to snap, yell: *Let's go the fuck back!* But no one did. I missed my grandmother the most. (There is forever a roller coaster drop in my chest when I think of her.)

I tried to assimilate. Six months into my ESL class, I challenged myself to write a short story in English. I sat with my dictionary and carved out words, those words rock-heavy as I lugged them up the slippery hill where I tried to build my story. It was a grotesque monster: the smaller rocks underneath the big ones, the construction absurd, falling apart. I didn't know the language.

Mute, I felt mentally ill from loneliness. I woke up with it and fell asleep to its insistent drone. I observed my schoolmates, Canadian girls. I tried to learn which ones were losers and which ones were cool. Those were new words, although I knew their meaning in Polish, too. There were other words: popular, slut. There were girls with dead eyes, coral lipstick, teased-up hair like halos. There were girls with pink hair and boys' clothes intentionally. Slut and popular, respectively.

There were other girls, but you needed a key to all of them: language. Language was necessary to be a girl here because girls talked. Once, Nasty Nancy said to go back to my country. I understood that, agreed. Slow Sarah was friendly, but she was a loser and I didn't want to be seen with her. She'd always want me to repeat what I had tried to say. And she would ask, like everyone else: Do you like it in Canada? As if they all invited me here.

Fuck you.

I moved out of talking. Now I lived in a library. I started reading. English books from the YA section. They had large fonts, easy words. Christopher Pike: *Gimme a Kiss, Fall into Darkness, Die Softly, Bury Me Deep*. In Polish, it was *On the Road, Lolita, 1984, Justine*. In English I was 10. In Polish I was 17. The first book I read in both languages was *Anne of Green Gables* —I loved it as a child and now as a teenager I could orient myself around it because I knew the story. Two different

languages to make sense out of one.

This is how it was: two different languages, two different lives. In Poland, during summers, I played with words, played with boys, boys playing back, all of us smoking in dives, talking about Witkacy and Gombrowicz. In Canada, I couldn't recite a joke I'd rehearsed a hundred times. On Wednesdays I waited for this guy in front of a club where he worked as a busboy. He would take me upstairs to his crummy hotel room. I was weird, he said, because I never talked. Fuck that guy. But I dreamed of the time when I could tell him a joke. Without that joke I was just a Wednesday girl.

It was like that for many more years. Every year it was better but I was never so fluent that I could float. I was in a flatline of blackouts for the majority of my twenties, but when I wasn't, I absorbed words. Maybe I absorbed them soaked in alcohol with bar shitfriends when I wasn't paying attention.

With words, came people. Real friends. Lovers. Experiences. Jokes. Humour had big loud elbows and was elbowing itself into crowds of hugs. I never hugged in Poland, but here everyone hugged, so, fine: hugs! Hugs! And I apologized. To people stepping on my toes, bumping into me, I apologized for coughing, for apologizing. Fine, I'm sorry! I'm sorry!

I was assimilating.

Furthermore: I read *The Handmaid's Tale*. I did an independent study project on Robertson Davies. I re-read *Lolita* and *1984* in English. I stopped reading Polish. In English, I was becoming fluent; I was floating. I learned what it meant to live in subsidized housing and how that was exotic to those who never had to. Write about that, people said.

So here I am, writing about it. Because I eventually started writing, too. Then I was fully assimilated. Then, once I was assimilated, I started loving it here. And I got sober here. In English. (The meetings were in English.) And I had a kid here. And then it was my home. And now here I am.

Sometimes I stumble over a word when speaking or writing. When I see it but can't name it. The words get mixed up in a pile at the bottom of my heart; they come up Polish when they should be English. They show up in a line of easy stock phrases when the desire is to dress them up in couture. They are missing articles or they have extra articles. I will never fully understand articles. The same space where those live in an English brain, in mine is probably crammed up with ą, ć, ę, ł, ń, ó, ś, ź and ż. Useless letters until I read a Polish book.

I started reading Polish books again. It had been a while. Years. But lately, I've been able to get books by tapping a finger on a square of glass. I read books on my iPhone. iBooks. This is how I returned to Polish. There is a Polish app with Polish books, so I picked three authors to start: Manuela Gretkowska, Michał Wiśniewski, Dorota Masłowska. Their words are brave, playful. They write how I think now as a writer, in the language that I used to think in. I will probably never write in it. I miss it. Like a love long gone. I'm writing about it in English, about my first love. It's always here. An undercurrent of the river I'm floating in.

Jowita Bydlowska is a regular contributor to Hazlitt *and the author of* Drunk Mom. *She lives in Toronto.*

Tabloid Fiction: Billie Livingston Lynn Crosbie

In which an author chooses from the trashiest, most lurid, or just bizarre stories of the moment and writes a short story inspired by same. The following are works of fiction.

ILLUSTRATIONS BY LOLA LANDEKIC

A Watch in the Night

Billie Livingston

> "We rolled into [Oceana, West Virginia] just as the sun was going down... We noticed that a lot of people were hitchhiking and, being the poor decision-makers that we are, we decided to pick a few up. The first person we met told us about the dark underbelly of the town while he shot oxycontin into his hand, in front of us, within minutes of our meeting him. It was clear to me that what was going on wasn't normal... A few months later, in April 2012, we went back for a visit and decided then to do a portrait of the area, its people, and the Oxycontin epidemic."
> -Sean Dunne, director of *Oxyana*

Do you know what day it is today?

The man just got here and he wants to know what day it is. A day late and a dollar short? A cold day in hell? It is a timeless question—it suits the room. A white white room. White as a scream, floor to ceiling, bed to nightstand. Maybe it's supposed to feel clean, but in truth, we're locked in the circumference of a second.

Can you tell me your name?

When you say you, do you mean you? Or him? "You" is always other. Of course "him" is also other. Do you mean Ben? Benjamin?

Which do you prefer? Can I call you Ben? Do you know how you ended up with those bandages on your head, Ben?

Dr. Lambert wants to know about the hole. The black hole. If he stuck his finger in, surely Lambert could find a day in there. They shot him. Boy, they did. The boy did. Meant it, too. Muzzle to the forehead. Point face, point blank, point of it all. Bullet in. Bullet out—now that was cheating. Shouldn't be above ground. It's not a trampoline down there. It's hell. You get what you deserve. Don'tcha think?

Is that what you think?

Lambert is not the kind of doctor who puts Humpty back together. He's the kind who roots around in your brains 'til they dribble out your mouth. The kind who traps with phony fool-blue eyes, then tries to muscle into the black hole. Go ahead, buddy. Nothing but tar in there.

Not many survive a gunshot to the head, Lambert says. *What do you make of that?*

Survive? Who survived? Just because you save the body doesn't mean you save the man. Shell's empty. The chicken's gone.

Hm, Lambert says. *So, I'm talking to a shell. Where is Ben?*

Wandering in the desert.

And who am I talking to now?

He's a crafty sonuvabitch. Give him that.

Why don't you tell me how your body got here, and we'll get to your self later.

Self. Is that like a soul? Joke's on him. How does anyone get here? Let the black hole speak: Ben should've been with his wife and kid. But he killed them and they killed him right back. First off: He should have manned up and gone to work on his birthday.

Lambert's got a face like a graveyard when he says, *Why don't we talk about that. You're employed as a chauffeur, is that correct?*

Correct. Ben was driver to the stars and the wish-they-were-stars. Made an extra buck where he could. Maggie cleaned apartments. Twelve bucks an hour. Oldsters mostly. The old ladies loved Maggie. They wanted to give her the world, but all they had was Medicare. So they tipped with pills instead. Old vials of Percocet, Xanax. . . Ben would sell them to the hungry selves in the back seats. Few bucks here and there. Enough to keep the lights on.

Then Ben's 35th rolled around. The limo service wouldn't give him the night off, so he called in sick. Ben and Maggie had a little birthday party in the living room. After the baby went to sleep. It's hard to get a two-year-old to bed. They did it, though, got him settled and closed the door. Put on a little music. Happy Birthday! Let's get high! Couldn't afford weed, so they popped some old lady's Xanax. Poured a bit of wine. A perfect night, the way the breeze blew the curtains, the moon shone through the window. Ben and Maggie dancing. Just the two of them floating in the kitchen. And then suddenly the baby. Little Frankie climbing up the couch, standing on the windowsill with his hands against the moon. As if he would be taken up. It was a vision. Small hands on the window, pushing until it opened into the night, into the universe. Ashes, ashes, we all fall down.

Happy Birthday, Ben. If he had any balls he'd have followed Frankie out the window. But no, not him. The baby broke and so did Ben and Maggie. No more

Frankie. No more Maggie.

See, there's Ben on a Saturday night all alone in a diner, mouth full of pancake and feeling sorry for himself. It's actually Sunday morning, but nobody in here's been to bed yet. If you look past Ben out the window, you can see his brother, Cola, coming up the sidewalk, skinny and pale under the streetlights. Cola shoulders his way through the diner's front doors and stands there squinting under fluorescence. He sees Ben at the window seat, shakes his head, no, and heads to a seat farther in.

After a minute or so, Ben hears *psst*. He's too tired for punk brother shit right now. Been driving all night. He looks out the window, watches a couple of the night's last stragglers stumble against the dark windows of his curbside limo, and knock on the glass before they wander off. From over his shoulder, another *psst. Ben*!

He can feel Cola wiggling in his seat the way he did when they were kids. He pictures that diner off the highway. Twenty-five years ago. He was ten and Cola six. The old man finished his second beer and had gone to take a leak when the waitress set their plates on the table. House rules: No eating without Dad. Dad took forever. Probably had a bottle in there, busy making his beers into boilermakers.

Cola got fizzy with waiting. Quit screwing around, Ben told him. But he didn't make him stop. You could argue that Ben has always been an empty shell.

Tongue between his teeth, Cola picked up his plate of spaghetti and balanced it on the point of his knife. He gave the plate a spin and wound up with the whole writhing mess all over the table, the floor, and himself.

The old man hauled Ben outside. "That's my money he was dumping on the floor! Little shit-for-brains—you just sit there?" Slap in the mouth. No saving face. The face is the first to know.

*

A whistle shoots from the space between Cola's front teeth. He coaxes Ben with a jerk of his head. A waitress pauses to fill Cola's cup. Ben watches the jut of her hip. She's young enough that even stiff brown polyester looks half decent. She's lurking for an excuse to push that flop of hair out of Cola's eyes, take him home and keep him for a pet. Forget it girlie, Cola's too busy trying to spin plates.

Ben wipes his mouth, picks up his jacket and schleps to his brother's booth. "Why'd you sit at a window?" Cola says. "I can't be all exposed like that."

"Exposed? Who're you, Al Capone?" Ben takes a seat. "You must owe someone a real chunk of change this time."

"I'll pay 'em back next week." He sets his tongue between his teeth as he dumps sugar into his coffee.

Ben shrugs. "Tell them to get in line."

"It's no joke. Dudes were waiting outside my place last night. Had to stay at Vera's. Man, you still not sleeping? You look like shit, brother."

"How much are you into them for?"

"Eight grand."

Ben stares.

"It was a sure thing." His voice quiets. "Oxycontin. Buddy had a shitload of it." At Ben's confused face, he murmurs, "It's like morphine."

"I know what it is." Ben blinks, waiting.

"You see that movie, *Oxyana*? I never watch documentaries, but it's about this town across the border in West Virginia. All anyone does there is score dope. So, check this: buddy sells to me for 10 bucks a tab, I go down to Oxyana and move it at 50, 60 a tab. I'd be sitting on 40 grand now." His eyes flit across the restaurant. "I borrowed the money, and fronted the guy eight grand. Now I can't find him."

"For how long?"

"Two weeks. Maybe he got busted. S'okay, I got another plan."

"To prey on a bunch of addicts?"

Cola laughs. "Hypocrite. Just 'cause you never had the balls to think big."

Ben nods at the table. "Who's the asshole?" he mutters. "Barely pay my rent. Can't look after Maggie."

"Maggie? Why you gotta look after her? Not like she needs—." Cola stops. He looks at Ben. "I mean, she's alone. It's not like—."

"I gotta go." Ben's jaws work as he pulls out his wallet. He slides out a ten-dollar bill. "Oh wait, you're broke, right?" Cola is silent. Ben chucks a twenty on the table.

"Come on, don't get all pissed. I got a plan. This time next week, we'll be cool."

"I got to get the car back." Ben stands.

"All right. Get some sleep, man. Seriously."

Ben heads for the door.

"I'll call you," Cola shouts after him. "If you talk to Maggie, say hi."

*

Lambert is back again. *Why don't we pick up where we left off yesterday*, he says.

Yesterday?

Used to be an old Jamaican lady who ran the corner store. She'd say, A

thousand years in God's sight are like yesterday—already past—like a watch in the night. The old man would bitch all the way home, Christ, I aged about 50 just waitin' for my change.

What do you think that means, a watch in the night? A watch in the night is like a thousand years in Ben's soul. Like a thousand white rooms. A thousand bullets to the brain.

Pick up where we left off: Cola's big mouth, that's where. Ben gets a call from him late Tuesday afternoon. He wants to meet Ben at the old diner off the highway. Same place Cola tried to spin plates. Cola and his diners. It's deserted now. Nothing but chipped wood and peeling ghosts. Ben pulls up in front of the diner in a pink super-stretch.

Cola can't take his eyes off the limo. He's jittery, laughing like a Tommy Gun. "Ha ha. Pepto-Bismol on wheels."

"Had an airport run for Mary Kay cosmetics," Ben says. "They've got a thing for pink."

"Ha ha. Barbie's Dream Car."

Ben faces the diner, the burned-out sign. Can feel that smack in the mouth all over again. "Get to the point, Cola."

Cola blinks. "I went by my place this afternoon. Those dudes were gone. Door was open and my place was trashed. I don't know if it was them or Vera. My pillows, my mattress was all hacked open with a butcher knife. Knife was stuck in the floor!"

"Why would Vera do that?"

Cola opens the trunk. Inside are two cardboard boxes. The shipping bills say Creature Care Clinic. Cola's new girlfriend, Vera, is a veterinary technician.

Last night, he explains, Vera had to hang around waiting for the courier to drop meds. Vera's clinic is central to a chain of animal hospitals, the clinic from which all is distributed.

Cola reaches into a box and pulls out a small vial of powder with a yellow label. *Telezol*. "It's a painkiller," he says. "And a sedative. It's sweet. You talk to God with this shit. You dream and wake up feeling like truth. Me and Vera did a couple caps of it each. We fell asleep and I woke up first. That's when it hit me. Who needs Oxycontin?" Cola looks at his buzzing cell. "She is pissed, man." He checks his voicemail and holds the phone to his brother's ear.

Vera screams an incredulous, "You stole my fucking *keys*? You stole my fucking *car*?" Vera is being investigated. They don't believe her keys were stolen. Vera is going to cut off Cola's balls with a rusty knife.

Ben waves the phone away. "They can track you through your cell, you know."

Cola's eyes bug. He pelts the phone to the ground and stomps it.

Ben looks at the mangled cell. "You stole your girlfriend's keys, stole her car, went to her workplace and stole pharmaceuticals. After you took dog dope that made you feel like truth."

"Don't make it sound all shitty. I gotta get her car back. Can you keep the boxes for me?"

"No." Ben walks back to the car.

Cola chases. "Please. I didn't come to your place. I'm not a total fuck up."

Ben opens the driver's door. "Put it in a locker somewhere."

Cola grabs his brother's arm. "Just 'til I get a buyer. There's 20 grand here, easy. I'll split it with you."

"No."

"I can't go home." Cola's eyes are welling up. His hair is flopping in his face. "What if those dudes are there? What if cops are watching? Ben. Please. You're my brother."

*

So, there's Ben in his crummy basement suite staring at the TV, feet resting on a box of dog dope. He surfs from channel to channel and sips a bottle of Bud. It's midnight and half the channels are playing infomercials. Girls in bikinis: *Call me!* He turns the TV off.

Silence. It crawls into his ears and slithers down the back of his neck. He turns the TV back on. If he could just sleep. Sweet luscious sleep. He thinks of Maggie napping in the day with Frankie. Ben picks up his cell phone and hovers his thumb over the keypad. Don't do it. She doesn't want to talk to you. He opens the photo stream to an image of Maggie with Frankie on her lap. He looks at Frankie's small damp hands on either side of her face. Ben stares so long, he can feel hands on his own face. This will not bring sleep.

The phone buzzes. Caller ID reads: Pay Phone. Ben answers. "Where are you?"

"Listen, don't be pissed with me. It was in the lock-up at the vet's. I don't know why I took it. I don't even know how to shoot one."

Ben looks at the box. "Cola! You better get this shit out of my place."

"I will. Hey, if you can't sleep, I made some capsules. I'll call you." And he's gone.

Chucking the phone on the couch, Ben pulls open the nearest box: row upon row of vials. Tossed on top is a clear bag with a label that reads "1000 '00' Gelatin Capsules." Beside it is a flimsy sandwich bag with about 20 filled ones. And then, wedged into the side, he sees the black butt. He eases the gun from its hiding place. It's a revolver, *Smith & Wesson* printed down one side of the barrel, *.22 LR* down the other. He opens the cylinder. Brass bullets in all eight

chambers. Closing the gun, he sets it back in the box, and lugs both to the closet.

He lies on the couch, pulls a cushion behind his head and stares at the ceiling. He thinks of the landlord up there with his neat little family. Never hear a raised voice, never a coarse word. They must sleep. Long fearless sleeps. He closes his eyes and sees Cola in front of the old diner. *It's a painkiller. And a sedative. Sweet.*

Twenty minutes go by. Thirty. He rolls toward the TV, opens his eyes.

He gets up, goes to the closet, and plucks out the sandwich bag.

Back on the couch, he takes out one of the filled capsules, lets it roll down his palm. *We fell asleep.* He rests the capsule against his lips a moment and then sips it onto his tongue. He sips his beer, lies back, closes his eyes and waits for sleep.

Half an hour later, his eyes snap open. Cola said they took a couple each. Ben must have 50 pounds on Vera. He opens the bag and takes out two more, swallows them, one at a time with a slug of beer.

A minute passes, an hour? Soon Ben is sleeping in a meadow. Prisms of sunlight, warm earth. Sweet. Just like the man said. He turns his head and sees Frankie running in the grass. Squealing with laughter, his son tumbles into his side. He climbs onto Ben's chest and takes his face in his hands. Ben closes his eyes, inhales Frankie's applesauce breath. The damp hands leave his face and Frankie says, "Don't be pissed off at me. It was in the lock-up at the vet's." Ben's eyes open to the barrel of a Smith & Wesson, Frankie's hands wrapped around the gun. The barrel jiggles when his son laughs. "Ha ha. Barbie's Dream Car." Ben slowly brings his hands up. Frankie squeezes the trigger and the sky explodes into darkness.

Ben wakes. He is in his basement suite. He turns his head. Beside him is a naked man crouched on the coffee table, knees up like a gargoyle. The man smiles. As Ben's eyes adjust it's clear who the man is. "If you're me, then who am I?"

The other Ben giggles and disintegrates into specks of darkness.

Ben sits up. The TV is off, but he can hear kid's music. Xylophones. He feels the weight of another body behind him. Hands land on either shoulder, hot stinking breath against his ear. Words vibrate through his bones: "You never existed in the first place."

Ben throws an elbow back, hears the smash. Heart pounding, he stands and looks at the lamp on the floor. The ceramic body is a doll's now, blood leaking from its cracked skull. The eyes are lit from within. He kneels down and the rancid breath is in his ear again: "Easy, Killer." He jerks upright, but the words

pull him inside-out until he is standing inside his own skull, his own private hell. Clothes melt against his skin. He pulls off his shirt and flesh peels with it. "Get out of my head!" And just like that, he is sucked back through his own eye sockets, the eyes of the planet, the eyes of God. Falling through the air in a rush of embryonic sludge, he lands with a squelch on his couch.

Ben sits up, panting. Hand on his face, he rubs himself awake, turns his head to see himself perched, naked at the end of the couch. "You're not real," Ben says.

"No, you're not real." A hand shoots out, takes Ben by the ankle, and yanks him down the hall to the woods. The hand on his ankle is a small child's now and the boy drags him like a stuffed bear up the side of a hill, his flesh snagging on rock and broken branches. At the top, the boy stands at the edge of the cliff and gazes out to the stars. "Now, you go," he says. Ben looks out to the moon, down to the infinite darkness and sobs as he steps off. Falling and falling, he shrieks in terror but no sound comes.

He bolts upright on the couch, tears streaming.

Beside him, naked Ben reaches to the coffee table and slides the gun closer.

The light of the television shimmers off the stainless steel barrel. Ben picks up the revolver, puts the muzzle flush to his forehead, and whispers, "Please, wake up, please wake up."

An explosion sends him somersaulting through space, through time and drops him in the desert. He watches as the other Ben salutes him and walks toward the sun. In the hot glare he picks up his cell phone and dials Maggie.

*

Do you know why you're here?

That's Lambert: All question, no answer. We're here because we're here. Hear hear. The buck stops here.

Seems that way, doesn't it. He takes one of his slow epic breaths. Like he's got all the time in the world. *Where is Ben now?*

Ben is lurking in the back of a skull, scuttling from shadow to shadow, his head ducked, begging to come home.

Lambert nods. *So, we're all here together.* The creases around his eyes deepen slightly. *Do you wish that bullet had done the job?*

If Ben was trying to do a job, he did a piss-poor one. He didn't plan to do a job.

Nobody shoots himself in the head by mistake. You tried to kill yourself.

Nobody tried to kill anybody. Clearly, Dr. Lambert, you are out of your depth. You are lost in the white, white world of—

You shot yourself in the head, Ben.

Yes. No, I—. The word "I" feels like an electric chair. He didn't want to die. He wanted to wake up. I—It echoes. Like an onus, an accusation.

Just to wake up. To get the hell out of hell. Nobody's got a chance in hell.

Lambert sits forward a little. *You're here*, he says. He watches, searching and his eyes are steady. They're not fool-blue. They're faith blue. Mercy blue.

I'm glad you're alive, Ben.

At that moment, Lambert's voice is as gentle as peace, and its tone vibrates in my guts until a howl erupts and the white room shudders with the force of my sobs.

Billie Livingston is a fiction writer, poet, and sometime essayist who lives in Vancouver, B.C. Her latest novel is One Good Hustle. *She regularly contributes* Tabloid Fiction *to* Hazlitt.

Blood and Guts in Charm School

Lynn Crosbie

"Lindsay Lohan: I Need Professional Help"
(*The Hollywood Gossip*, 16 Dec 2012)

Long before I played Antigone on Broadway, when men rended their garments and, in their sea of crying, women placed their immaculate white gloves; before the gold statuettes mustered at my name, calving gold foals; before I was deemed the most "luminous of the asterism" by a *Vanity Fair* writer who would commit suicide with a pair of my sheer stockings, I went to Sparkles Charm School, on South 15th Street in Las Vegas.

*

I met him in Bungalow 3 of the Chateau Marmont. He scared my friends, but Wladziu (charm instructor, concert pianist, and coke dealer), "Lee" to his chauffeur, had the best *Illello*[1]: iridescent and smooth as silk.

He wore bandages around his entire face, dressed in an ermine trench coat and slacks: and wore a red-feathered chaplet.

"Belushi died up in this shit," he observed, the night he waved off my money and staked out his place in the centre of the burn-scarred white leather sofa.

"No coke, Pepsi," he would say, and laugh. If one of my friends joined him, he would stop immediately, scaring them more.

But he loved me, "Sit on my lap Misty," he would croon, and from this bony perch I listened to him warble "My Funny Valentine," as one of his sequined gloves caressed my nude, shivering thigh.

1. Old-school slang for cocaine.

*

Not long after *Liz & Dick* aired, after another arrest and violent incident, he came for me. He filled his attaché case with a square of white cotton, chloroform, rope, a knife, a red textured notebook, and a leather-bound copy of *Mondo Monologue*.

I was half-dressed for a screening, and squirrely. I ran into his arms and he twirled me around, then led me down Marmont Lane, where a black Lincoln Town Car idled.

"I hope this will not be necessary," he said, springing open the case.

"Just give me the books," I said, scowling.

*

"I'm going to teach you to act like a lady," he says. "How to act period."

He says this gently, but the pink-chick-feathered shank he is holding to my

face is so sharp the sheets are notched with my freckles.

"Criss-cross," he says. "I need money to refurbish the Lady," which is what he calls the conjoined bungalows, or mansion.

"And I need muscle. Fascia, nerves, blood, skin—"

"So the deal is," I say, "that I get to be famous and you?"

"I shall be the beautiful Toshiyuki Hosokawa, as he appeared in *Eros Plus Massacre*," he says, "and you will not merely be famous, you will repent."

I am kept in the Cowboy Room. For the next 24 hours I watch, projected on the walls and ceiling, drunk drivers kill men and women and children.

I watch their bodies fold into cranes and flowers as "Sailing" plays brokenly through speakers embedded in the denim legs and lariat of the night-table.

Their mouths form the word "No," then "Please," or "Please, God," before their lives bleed out.

*

I finally break, and, crying, I write on the square of paper he slides through the door: Half-slip, bra and heels:/ It is time for guts and God!/ Skyline, bumps of stars. He grunts and slides back *The Duchess of Malfi*, which I read by the fuzzy neon of the old Vegas strip until I am ready to perform for him.

*

And it is in the Rose Room that I first make him clutch his chest with anguish; it is by the fire we build with paper and sticks in the Moroccan Room where he stands and applauds until his bindings loosen, revealing blue-white bone.

*

"I'm not a welcher on bargains. Drink it all. All. All!"

I recite Hannah's words and hand Wladziu a hot cup of tea, while balancing three copies of *Shogun* on my head and curtsying.

He pulls out the pearl-handled revolver and we start the drill that began the night he had me fold a white gag into a swan, dip its beak into chloroform, and inhale.

He aims the gun at my feet and barks out topics I may be asked to discuss at "high society affairs."

"The Côte d'Azur! Hezbollah! Château Mouton Rothschild! Bizet, Blake, Becquerel!"

I balloon around the gunfire and extemporize short, thoughtful remarks; I

set a table for ten as he torches the centrepiece. I remove blood stains from my tea gowns while needle-pointing the Piss Christ and play the Elgar concerto on a bottle-mouth strung with catgut while supervising the decoration of the Victorian Romance Room.

I study and write, in white gloves and a pink pillbox hat: at night there are the images and the sounds; there is a film of my face changing; of it bloating into a nightmare to the sound of butchered pigs screaming.

*

He massages me morning and night with coconut butter, combs my red hair, then coaxes it into shining waves.

I eat raw food and drink ice water, swim in the pool he fills with a bucket, and every night, we light candles in the living room and after I recite for him, he plays his favourite songs on a Pianosaurus.

He tells me how the Lady looked before foreclosure, and one night we are so cold and lonely, we call each other Sam and have fast, shuddering sex in the Safari Room.

"Honey, what is better than orchids on a piano?" he asks dreamily, as we rest in the fallen mosquito netting.

"Two lips on your organ," I say, and let him handcuff me to my cot.

*

I am in the middle of Electra's soliloquy and I stumble on the words "the sorrows of her father's house."

"You'll never be ready," he snaps. He is getting weaker every day, and has taken to wearing sweats and an Expos cap.

"Fire-crotch," he hisses, and I stumble blindly to the marble bathtub, curl inside of its immensity and cry.

"I saw the poster!" I yell at him. "You are blowing bubbles right here, laughing, and it says 'No one will believe in you if you don't believe in yourself!'"

His bandages look ashen; he stands stock-still, then climbs in beside me, and holds me.

He captures each tear in a bud vase and apologizes.

"Miss Lohan," he says. "I would be honoured to present you to the world."

And he does.

*

Lynn Crosbie

From the wings of the Lyceum, where I have arrived after a flurry of arrangements for new management—the management that paid Wladziu a significant sum of money for his "tutelage" and silence—I see him shyly holding hands with a slender young man who looks like a handsome Scott Thorson.

I see my family and friends and column after column of pulsing red lights, rising from their hearts.

And in the front row, my own sweetheart. A dashing Tasmanian archer who appeared at my window the night we finished revamping the Lady, in a peaked, feathered cap and olive-green suit. Who kissed me and said, "You love me!" as the moon bellowed "Love Is a Many-Splendored Thing" and Liberace raced his jewelled hands across the keys of a baby grand.

I enter to apprehension that rages into applause, and—so quickly!—into massive waves of love.

By the time I begin my final speech, I am holding the audience in my hand like a small, drenched bird.

I am wearing a white toga and bare feet: two children kneel beside me, lapping milk from clay pitchers.

"Now I am going down," I recite.

Someone who was there later described my words as a battery of arrows; another called them a great cat's claws.

My mouth fills with water that spills out as blood trickles from my nose.

"Because I have been so ill and so lonely," I continue, "I could not stop; I would never stop."

"Thank you," I say, as I fall to my knees and the drowning men swim towards me and the drowning women drown.

"We're losing her," someone says, as my dreams—in love and playing "Over the Rainbow" on the gigantic keys of the swimming pool piano!—sink, waving little white kerchiefs.

"We lost her," someone cries as my heart ejaculates a straight red line.

Their grief is my final thought, a thought in a pressed gray suit and black veil, its ankles crossed neatly. A thought that twists into a feeling, joy, before it passes.

A feeling not mindful of "LiLo's Sad, Final Days!", of boxes of lingerie, scarves, perfume, brushes, makeup and paperbacks including *Mr. Showmanship* and a Moroccan-bound notebook filled with chicken-scratch poems and plans.

My story is short. It surges then passes, quickly, among some concerned, then laconic, talk of waste and compulsion, lies and beauty, failure and forgetting.

Lynn Crosbie lives in Toronto and is a regular contributor to Hazlitt. *Her latest book is* Life is About Losing Everything.

Album VI (2007)

Luis Jacob

Image montage in plastic laminate
162 panels, 44.5 x 29cm each panel

Collection of the Museum of Modern
and Contemporary Art (Museion)
Bolzano, Italy

(excerpt: panels no. 142–149)

COURTESY OF BIRCH CONTEMPORARY, TORONTO
AND GALERIE MAX MAYER, DÜSSELDORF

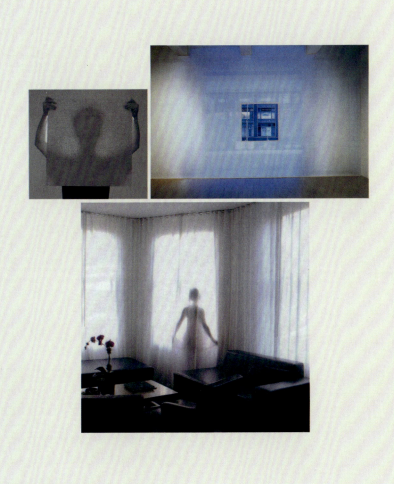

'I Bet Your Mama was a Tent-Show Queen'

Carl Wilson

Fifty years ago, a gay, cross-dressing, black singer named Jackie Shane scored a surprise radio hit in what was then staid and uptight Toronto. A few years later, he disappeared. On Shane's legacy, and the underappreciated gifts he gave to a sometimes self-congratulatory city.

ART BY MICHAEL COMEAU

Half a century ago, a local hit invaded Toronto's radio charts at no. 2, sandwiched between "He's So Fine" by the Chiffons and Skeeter Davis's "The End of the World"—a rare enough thing in the time before Canadian Content regulations birthed a functional Canadian music industry. The song itself, though, was an even more exotic bird, a cover of an American rhythm-and-blues tune called "Any Other Way," by Toronto-based artist Jackie Shane.

With its quavering, caressing vocals and that androgynous name (as in Jackie Robinson or as in Jackie Kennedy?), many casual listeners reportedly thought the

song was by a woman. On the other hand, then-teenaged fan Carole Pope (later of Rough Trade) told me, "It was obvious to me and my friends he was gay." Shane was in fact a drag queen who had made his way to Toronto from Nashville and, by that point, had been enthralling crowds on the Yonge Street strip for a couple of years.

The key to Shane's take on "Any Other Way" was that, live, he'd give a little chuckle or quip, "Make sure you tell her this!" before the chorus, "Tell her that I'm happy, tell her that I'm gay, tell her that I wouldn't have it"—rimshot—"any other way." What had been a face-saving fib by a brokenhearted guy in the original William Bell and Chuck Jackson versions became a wink of defiance from a queer tranny glad to have given denial the slip.

The Yonge Street scene was, along with the nascent bohemian coffeehouses in nearby Yorkville, a patch of libertine hipness on Toronto the Good's otherwise straight-laced map. (Even these clubs had to go at least nominally dry by 12 on Saturday nights, because the Lord's Day Act forbade Sabbath drinking.) They hosted local R&B bands as well as touring groups in town to play Massey Hall or Maple Leaf Gardens: Cannonball Adderley, Stevie Wonder, or James Brown's band might drop by the Blue Note or the Colonial to jam after hours. But nothing was as hip as Shane, in shimmering pantsuits, heels and perfume, delivering the news from the future in the middle of a funky breakdown:

> "You know, when I'm walkin' down Yonge Street, you won't believe this, but you know some of them funny people have the nerve to point the finger at me and grin and smile and whisper. But you know, that don't worry Jackie, because I know I look good. And every Monday morning I laugh and grin on my way to the bank, because I got mine. I look good, I got money and everything else that I need. You know what my slogan is? Baby, do what you want, just know what you're doing. As long as you don't force your will and your way on anybody else, live your life, because ain't nobody sanctified and holy."
> –*Spoken break in "Money (That's What I Want),"* Jackie Shane Live

Shane heated up Yonge Street for most of the decade: He and his band arguably taught the town how to play fatback bass. But in 1969–70 he abruptly told friends he had to leave Canada and vanished, even before the loosening of burlesque rules transformed most of the Yonge clubs into nudie bars almost overnight in 1975. Neither his other singles nor the live album recorded at the Sapphire Tavern in 1968 ever reached the heights of "Any Other Way."

For ages it seemed like the city had forgotten the Yonge Street scene in favour of the Joni-and-Neil Yorkville saga, aside from the recitation of how it gave the world Ronnie Hawkins and the Hawks, who met their boomer-rock destiny as The Band. But lately there's been a bit of a revival, with director Bruce McDonald's fine 2011 Bravo documentary *Yonge Street: Toronto Rock & Roll Stories* and, a bit earlier but less-noticed, Elaine Banks's CBC Radio "Inside the Music" investigation *I Got Mine: The Story of Jackie Shane*.

Banks's is the definitive work to date, among much else debunking the story that Shane was killed in a knife fight or bridge jump in the 1990s—one of Shane's

former bandmates talked to him on the phone at least as recently as 2005. (Another former Torontonian now in Britain, Jeremy Pender, claims to have spoken to Shane even more recently, and says he now lives full-time as a woman, a position reinforced by at least one online witness. With hesitation I've decided to stick with the pronouns by which s/he was known during the Canadian stint.)

But most of the way the story gets told tends to imply Shane was an out-of-nowhere, one-of-a-kind phenomenon—the closest anyone could come up with at the time was Little Richard—thus the dubious rumour that Shane was the cousin of the gay rock pioneer, whose "Tutti Frutti" in its pre-recorded version was an exuberant ode to anal sex. There's a risk of self-congratulation involved, as if Canada were so much more tolerant and evolved that Toronto served as a refuge. And maybe there is something to that. But if you follow the swishing train of drag performance in African-American life, and the shape of queer things to come post-Jackie Shane in Toronto, the script seems flipped: I think he brought us much more than we gave him.

The Big Tent

Jackie Shane was born around 1940 and—for reasons unknown but not hard to imagine for a queer teen in the black South of the time—spent some of his teen years living with Nashville "queen of the blues" and musical house mother Marion James. Elaine Banks guesses that he started performing and touring in his late teens, leading up to the day in 1960 when Frank Motley's touring band picked him out of a crowd at Montreal's Esquire Showbar. In Banks's documentary, bassist Larry Ellis remembers that Shane mentioned playing "circus sideshows."

That sparks thoughts of Southern black "tent shows," travelling variety entertainments under canvas that could either be actual PT Barnum-style circus sideshows or just called circuses in themselves. Many were linked with itinerant patent-medicine sellers, independent theatre troupes, or touring companies representing nightclubs from the chitlin circuit—the network of clubs, bars, juke joints, fraternal lodges, and other venues that made it possible for black entertainers to reach black audiences and travel in comparative safety from north to south. Most of the famous black entertainers of mid-century—from Count Basie to Richard Pryor—did time on the circuit before crossing over, while others spent whole careers there.

Whether in tent shows or circuit clubs, drag queens—known as female impersonators—were common. Little Richard himself played Princess LaVonne, balancing tables and chairs in her mouth, in a "minstrel" show (a term that held on long past its antebellum infamy) run by "Sugarfoot Sam from Alabam." Richard was avowedly influenced by Esquerita, another piano player whose drag shtick was even more flamboyant and whose bouffant was even higher, and who enjoyed a brief R&B recording career when rival record companies were looking for Little Richards of their own. Both took after respected blues singer Billy Wright, a gay star in and out of drag from Atlanta who had regional hits in the late 1940s and was a dab hand with a makeup brush. Other R&B stars with backgrounds in drag likely

included Rudy Ray Moore (later blaxploitation "pimp" star Dolemite), Bobby Marchan, Larry Darnell, and many more.

The drag capital was New Orleans, with its polymorphous, masked-carnival tradition. The popular Dew Drop Inn was hosted for decades by beloved drag queen Patsy Vidalia, and Little Richard, a Dew Drop regular, found his recording mojo in Cosimo Matassa's French Quarter shop studio ("tutti-frutti, good booty!"). According to Louisiana music journalist Alison Fenterstock, "It's clear empirically, in NO at least, that trans, openly gay or otherwise queer performers have historically enjoyed a special place in the black community here." It was a town where the most popular straight funk band, the Meters, could cut a classic called the "Cissy [Sissy] Strut."

"If you look at back issues of the *Louisiana Weekly*, NOLA's historic black newspaper, from the '50s," says Fenterstock, "every nightclub ad includes [drag acts] as an opening act for the main musical performer—multiple different house groups of female impersonators, it looks like, each with its home base at a different club."

She became familiar with this backstory chronicling the rise in the past decade of "sissy bounce" (a term she coined), the cross-dressing gay hip-hop style in New Orleans that's made stars out of drag performers such as Big Freedia and Katey Red. They're often said to appeal especially to women, who relish the chance to shake their thangs along with performers rather than for them. A particular connection with audience "gals" (as he'd call them) was a hallmark of Jackie Shane's live presence, too, especially in his spoken-word interludes unpacking the appeal of songs of love gone wrong.

But it wasn't just in NOLA. Preston Lauterbach, author of the recent study *The Chitlin' Circuit and the Road to Rock 'n' Roll*, says that the demand for drag was clearly widespread, and "straight dudes" he interviewed for his book praised the talents of a Memphis queen named Peaches in particular. Louis Jordan's "Caldonia" was said to be a paean to a drag queen, just like Little Richard's "Lucille" and "Long Tall Sally." As historian Marybeth Hamilton writes in her 1998 essay, "Sexual Politics and African American Music": "Female impersonators were featured in many of the rhythm-and-blues package shows that toured the North and Deep South, scoring hits in the most unlikely places—Mobile, Alabama, for example... Pompadoured, effeminate, and raunchily funny."

Check out these pages from *Ebony* magazine of March 1948, preserved on a tribute page to Chicago drag queen Petite Swanson, profiling Joe's DeLuxe nightclub on the South Side and its stable of "make-believe ladies." Shane himself, even after his Toronto success, would sometimes decamp to tour with the Etta James Revue (with an uncertain connection to the real Etta James), an ensemble including cross-dressed entertainers who played circuit clubs.

How much deeper it goes depends on how many hours you have. Lynn Abbott and Doug Seroff's 2007 study *Ragged but Right: Black Traveling Shows, "Coon Songs," and the Dark Pathway to Blues and Jazz* documents female impersonators in African-American tent shows back into the late 19th century. In New York, meanwhile, there was Frankie "Half-Pint"

Jaxon, the Harlem drag balls, the "mannish acting women" among the early blues queens (Ma Rainey and Bessie Smith, also minstrel and tent-show veterans) and all the gender nonconformists of the jazz age and Harlem Renaissance.

Personally, the first drag performance I ever saw was black comedian Flip Wilson on TV in the early 1970s, with his ultra-popular, sass-talking character "Geraldine," an archetype right out of the chitlin-circuit comedy where Wilson got his start. Geraldine is a cousin to the cornpone crossdressing practiced by Christian actor and director Tyler Perry today—his Madea plays and movies, huge in black America, are an enduring holdover, stripped of gay subtext, from a very old, broad, black comic style. Not everyone is thrilled by that.

Mammy, Sambo, Trickster, Hustler

That ambivalence hints at the multitudinous duplicities of crossdressing in African-American history. It's difficult to separate it, for example, from the legacy of minstrelsy: Blackfaced white minstrel troupes were as a rule all-male, and so would include performers who specialized in female characters, mostly degrading archetypes such as the Mammy and the Wench (plantation madonnas and whores). When black-run minstrel tent shows and their female impersonators took over, they sometimes perpetuated those characters, though they also added more dignified ones, just as they sang some of the "coon" songs and re-enacted jokes and scenarios from that ugly past. Scholar J.T. Lhamon reads Little Richard's act as a "Sambo" figure mutated, made a "trickster," by its acceleration through rapidfire postwar social modes—sum that up as "woo!" or "A-wop-bom-a-loo-mop-a-lomp-bom-boom!" (those last couple of syllables were originally "goddamn!").

Minstrelsy might be reclaimed and reconfigured, but its uneasy inheritance is everywhere, in American black and white.

Drag can also be hard to sort out from peacock-pimp stylizations that have likely more to do with cross-class impersonation —aspirations to wealth and masculine power, with the trappings of preachers's robes and even high-status fashions looking back to Africa—than with gender-bending. Prince clearly manifests both, but would you have guessed, as R.J. Smith's recent milestone biography of James Brown tells us, that Brown modelled his own style on Little Richard, Billy Wright and other "tent-show queens"? No one mistakes the Godfather of Soul as trying to look like a lady.

Drag might connect with the matriarchal line of black culture, but it doesn't prove black communities less homophobic. Drag can serve as much for mockery as for idealization. As Fenterstock says, "Your average overtly queer black guy like, say, the mailman, did not and does not necessarily enjoy the same privilege" as the entertainer, even in New Orleans. Marybeth Hamilton, who reproduces the sign of a black rooming house that specifies "No Female Impersonators Allowed," argues that the "freak" in early 20th-century black culture significantly diverged from the evolving idea of hetero and homo in the white world. In this working-class version, the "sissy" stood in for the destabilization of sexual identity that went along with the Great Migration from south to north, and country to city, when

There's a risk of self-congratulation involved, as if Canada were more tolerant and evolved that Toronto served as a refuge. But if you follow the swishing train of drag performance in African-American life, and the shape of queer things to come post-Jackie Shane in Toronto, the script seems flipped: I think he brought us much more than we gave him.

no one in the urbanizing black population quite trusted their roles, including the idea that a real guy could fuck a sissy in a pinch. Even a macho blues singer could drawl, "Woke up this morning with my pork-grinding business in my hand/If you can't bring me no woman, bring me a sissy man."

The fluidity of identity and masquerade that drag represents does recall W.E.B. Du Bois's famous invocation of the "double-consciousness" inherent to black life: "born with a veil, and gifted with second sight in this American world ... this sense of always looking at one's self through the eyes of others. ... One ever feels his two-ness." There might even be a more ancestral and metaphysical level, Fenterstock suggests, "attitudes from Africa and the Caribbean, where the gender-straddler often had a shamanic role," shuttling between the material and the spirit world. She notes that those traditions "weren't stifled as much in New Orleans as they were in the rest of the slave-owning South"—not to mention how suppressed they were by Christianity over the centuries for European-descended whites like most of Jackie Shane's Toronto audience.

Less romantically, the chitlin circuit and the tent shows existed—like so much African-American self-directed commerce and culture—on the margins of legality and respectability, as Preston Lauterbach amply shows, often dependent on gambling, bootlegging, pimping, and other underworld entrepreneurialism. If female blues singers often doubled as prostitutes, or were assumed to (the cruel import of glammy-pantsuited Mick Jagger's line "I bet your mama was a tent-show queen" in the sexual-slavery NOLA fantasia "Brown Sugar"), what did that imply for a dance-hall tranny? Note these encouraging words from the *Ebony* article on Joe's DeLuxe: "Joe's rules are few, simple and inflexible to stay within the law. A female impersonator must be a good entertainer, must not wear dresses and makeup outside the club, and cannot accept invitations to sit at customer's tables unless real women are present."

That kind of policing assumes there's something to guard against. Shane's live monologues, in a town where cross-dressing in public was likewise illegal (which may be why he never wore skirts), also drop hints around hustling, perhaps just as a metaphor for making coin in the clubs, but perhaps not:

"Mother told me, she said, 'Jackie,' she said, 'baby, I conditioned you,' ha-ha,

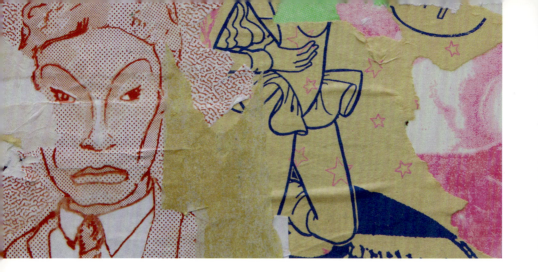

she says, 'because you take after me—don't worry about Daddy, because you'll get paid for what Daddy has to pay for!' And like always, Mother didn't lie, honey. I'm getting it each and every day of my life . . . I'm a little piece of leather, baby, but well put together. Ninety-eight on the seats and seventy-five on the sheets, and I got bedsprings on my bed singing 'Nearer, My God to Thee.' You know you got to have money to enjoy that kind of thing . . . I don't mean 50 or 60 dollars, I pay that for my French perfumes . . . [back into the song] . . . Baby if you wanna be mine, said you got to give me money baby."

He needed the cash, Shane said, because he was about to go on a six-month holiday—and he didn't want "to do nothin' but have breakfast in bed brought to me by gorgeous chicken." Chicken was of course gay slang for underage trade, often paid for, so at least Shane was expecting to have it both ways.

Queercore Confidential

By now it should be obvious that Jackie Shane wasn't bringing his act to Toronto so it could be better understood. Instead he was taking it out of context, to someplace where it seemed more alien and strange. Maybe he liked it better that way. By coming to Toronto he was escaping segregation and getting to perform to white people with presumably deeper pockets, who had never seen anything like him before. You could cross over in the States, but then you'd have to pull a Little Richard and turn your "freak" show into a clown act, taking out the gay innuendo. Little Richard has spent his life in an internal battle, betraying his gay self for his church self and then vice versa. Maybe Jackie Shane was a subtler creature, or, I'm sad to think, maybe he wasn't quite up to the competition.

After Toronto washed out—whether because of immigration officials, as I suspect, or club-scene changes, as Banks's documentary suggests, or because of the lack of any music industry to ascend in—there's little word of Shane making a splash anywhere else. Whispers have it he became reclusive when he got back to Nashville. Maybe there were family issues. We might never know. Whatever the truth, I have a sentimental theory that his stay in Toronto, trailing all that history and drag-queen shamanistic magic, left

something behind. Or at least uncorked it.

Carole Pope told me she didn't count Shane as a direct influence. And of course queer culture in North America was undergoing a revolution in total in the 1970s. But I can't help wondering if otherwise, a decade after Shane left town, Pope would have achieved a Top 40 hit with a band called Rough Trade and a song that fetishized a high-school Lolita making a hoarse-voiced female singer "cream my jeans when she comes my way." Certainly, trans and queer themes were piping up the highway from punk New York, but they became surprisingly dominant in Toronto alternative art and music, from the days of the Miss General Idea Pageant and other queer happenings in early 1980s Queen Street West, through the queercore zine and punk culture that followed (J.D.s, Bruce LaBruce, Fifth Column, etc.), and even the crossover success of *The Kids in the Hall*, then into the 2000s with the Hidden Cameras, Final Fantasy (Owen Pallett), the late Will Munro's Vazaleen (on the following pages, see Michael Comeau's posters for the Vazaleen shows put on by Munro), and most recently the straight-but-queer-impersonating Diamond Rings, etc. There's this impulse here to play queer for a larger, unsuspecting crowd and savour the confusion, like Jackie Shane did.

Can a nearly forgotten figure really be given credit? Likely not. But I choose to see him as a syncretic saint in this unsanctified pantheon. If Toronto can give more than their due to Neil, Joni, Robbie and others who passed through briefly en route to iconicity, why not to someone who wired up this backwater's bland aesthetics to one of the most fucked-up, tangled and beautiful AC/DC power sources in North American culture, then stood back—all the way back, right off the map—to let it run?

Meanwhile in hip-hop and R&B, outside the safe zones of New York and New Orleans, there's still a conflicted interplay between what kind of sexuality means just playing the "freak" role and what might be expressing some authentic self. Probable straight but definite Little Richardish clown Lil B calls an album *I'm Gay* to sew mischief, while Frank Ocean, Azealia Banks or Nicki Minaj come out but then dodge direct questions, and the likes of Missy Elliot and Queen Latifah, as rumours built, seemed to back away from music altogether. Given the borderline historical locations of the sissy man and the mannish-acting woman, it's a balancing act harder than Chinese algebra. We've seen it in the tippytoe course of Barack Obama, endorsing gay marriage, backing off from it and then "evolving" to endorse it again.

Better to take these words from Jackie Shane:

> "I live the life I love and I love the life I live. I hope you'll do the same. You know you're supposed to live. . . . The mean things people say about you can't make you feel bad, because Jackie can't miss a friend that I've never had. [*sings*] I won't have it, baby—[*spoken*] and I sing sexy too, that helps—[*sings*] no other way."

Carl Wilson writes about music and culture in many places, most regularly Slate.com *and* Hazlitt. *His critically acclaimed book,* Let's Talk About Love, *an inquiry into taste, class, and Celine Dion, is being reissued in March 2014. He lives in Toronto.*

Toronto After Jackie Shane Vazaleen, 2000-2006

Michael Comeau's posters for the queer rock parties organized by Will Munro.

"In its lewd, spontaneous, hysterical and glamorous way, Vazaleen defined a new Toronto aesthetic, a playful and endlessly inventive mode of presentation that encompassed everything from lesbian prog-rock to tranny camp to vintage punk revival to good old-fashioned loud-mouthed drag."
–R.M. Vaughn in *Toronto Life*

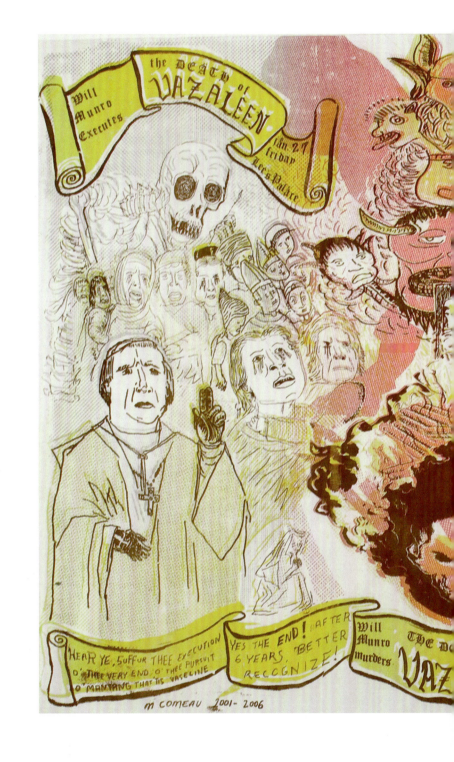

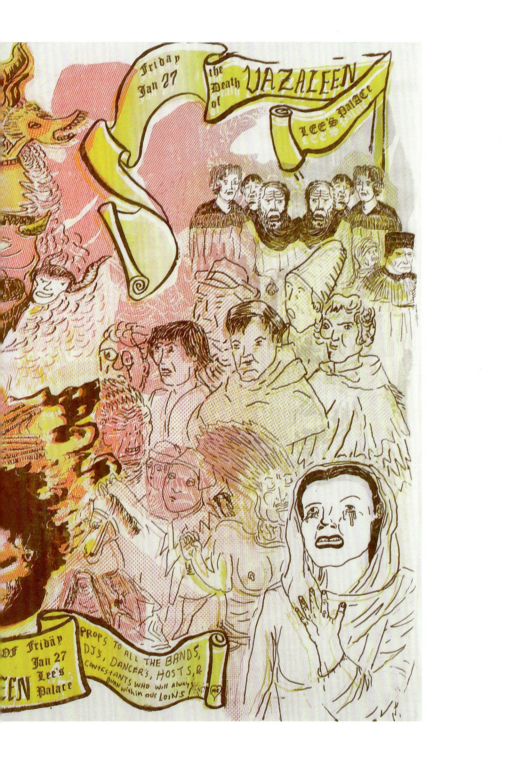

James Salter's Blue Moves

Sarah Nicole Prickett

Salter's depictions of sex as a glorious, writhing inevitability in *A Sport and a Pastime* divulge certain truths about companionship. Meanwhile, he paints the entire world blue.

CYANOTYPES BY HUGH SCOTT-DOUGLAS
COURTESY OF JESSICA SILVERMAN GALLERY

Until mid-April I had never read or wanted to read James Salter. In my head, he belonged to a class of old, manly American writers I knew to respect, but also to hate: Norman Mailer, of course; John Updike; Philip Roth. Someone I used to admire told me nobody writes sex like Roth, and after reading four pages of *American Pastoral*, I hope that's true.

One day, a Saturday, I sat under the Williamsburg Bridge watching a guy play tennis and not talk to me. We had been friends for four months, the latter 10 weeks of which we'd spent having sex less and less frequently, texting more and more. He invited me because he liked to

Sarah Nicole Prickett

have one or more girls watch him do things, and although when I looked at him I saw a great friend and possibly a genius, he looked at me and saw a girl. Yet, I stayed. I liked watching the things he did: sports, karaoke, the entire dance routine to "Dirty Diana." I wanted to watch him have sex with someone else, but when I said so he seemed not to believe me. It was that kind of relationship. It was also the kind of relationship in which he would never, not once, have watched me do anything. He didn't read things I wrote, which I felt was fine, a relief. But then he didn't read things I read, and that was not fine.

His tennis partner was older and had a wife and a kid. I played games with the kid that seemed expressly designed to bruise me, usually with yellow balls but also with shoes, a wallet, a small fist, and with the wife I talked about books. She seemed to like me because I was smarter than most girls who would spend a whole afternoon watching a guy play tennis, something I guiltlessly let her believe. I was reading Lorrie Moore. She was reading Salter. When I told her I'd never read James Salter, she looked like she'd found her purpose in life. She sat up straight. "James Salter is one of our favourite writers," she said. I liked her anyway.

After the tennis game, the guy and I walked to American Apparel, where he did not buy anything, and to a juice bar in the East Village, where he was dissatisfied with his order. Two of his friends met him outside. I smoked. The seconds went by like minutes, and then he had to be alone. I turned and left without saying goodbye or realizing I wasn't saying goodbye, just —it was a reflex, and in ten more seconds he texted that it was rude of me to do so,

Blue is the thingness of the novel. Was I reading it because I was blue, or was I blue because I was reading it?

that surely I hadn't meant to be so rude, and then again maybe he was just sensitive, but also, I was rude. I thought about never texting back. Then I called him.

What I didn't say on the phone was that it takes a particular kind of ego to make someone feel unwanted, then blame her for walking away. Well, what was the point. This wasn't the first time I had loved somebody who would never know how to be my lover, not really, and what difference would come of teaching him, in the spring, just so I could leave in the summer.

I was early to meet Durga. I felt light and sick, like the light before a tornado. It didn't rain. I found an old bookstore wherein the first Salter I saw was *A Sport and a Pastime*, in paperback, with the girl on the cover in her ochre stockings, the moss-coloured room, and I bought it. That night I went to a dinner party and fought badly with a very good friend. Dinner parties often make me feel murderous, but that night, I think, it was the other way around. I stormed out and went to sleep, but couldn't, and so from six a.m. 'til the sky turned blue I read.

Blue is the thingness of the novel. Was I reading it because I was blue, or was I blue because I was reading it? This is the wonder of a book you love, that you can't know; it's like a horoscope. It is true, but you don't know whether it would be true

Sarah Nicole Prickett

> **Nobody notes more colours than Salter's narrator. On the first page alone, we have the dark green of the coach seats, a grape-coloured birthmark, and then the blues of a suit, the blue jacket and blue pants, "blues that do not match."**

had you not read it. Had you not been looking for the thing. In mid-April, on a Sunday, *A Sport and a Pastime* made clear and true and blue as blue water my desire. I didn't want to be longing where I wasn't gonna stay. I wanted to be desirous and whole, like the book, which left its lovers with no choices, and so, although in the stream of three hours I stopped only to cry, at the end I was completely un-depressed. There's no ecstasy like this kind of reading. Suddenly I had loved this fucking Salter book since I was old enough to be a virgin. Less important was the idea that I should give it to this guy, who was like, so busy and so tired all the time, so that before I walked away for good, for better, I would have let him know—if he wanted to know—what I had wanted from sex: not another game, but a sport.

I had already begun underlining sentences I felt the most and the sentences I thought the best, and they were the same sentences and I was thinking of him.

Sentences like: "With a touch like flowers, she is gently tracing the base of his cock, driven by now all the way into her, touching his balls, and beginning to writhe slowly beneath him in a sort of obedient rebellion while in his own dream he rises a little and defines the moist rim of her cunt with his finger, and as he does, he comes like a bull." And: "These atrocities induce them towards love." And: "Nothing."

These and 100 or 120 more I underlined, and I underlined every instance, no matter how pale, of "blue."

The narrator in *A Sport and a Pastime* is a photographer, 34, living in "green bourgeoise France." His subject is the beautiful, shiftless Philip Dean, 20 or 24, I forget, but anyway being 20 in 1967 is like being 24 now. His other subject is the girl, Anne-Marie Costellat. Salter's style is consistently described as imagistic, to which I'd add "similistic," the book's best simile—on a train ride, "it's as if a huge deck of images is being shuffled"—being also its best descriptor. It's so good. When I read it I put my hand over my mouth. And yet the feeling is not of a still image, a photograph, but of a painting of a photograph, the way paintings used to be done, when reality was more truthful than we know it is now.

My own reality being generally a little suspect, I wondered again if I only saw so much blue because I was looking for it. The other day I re-read, played paint by numbers. And I was right. Nobody notes more colours than Salter's narrator. On the first page alone, we have the dark green of the coach seats, a grape-coloured birthmark, and then the blues of a suit, the blue jacket and blue pants, "blues that do not match." After black and white and dark and pale—almost nothing is grey in *A Sport*; it's all soft, flashing chiaroscuro

—the colour of most things is blue. Carpet, the car Dean drives, and the sky, of course, but also things that don't have to have a colour, like cities. Light is blue. Flesh is blue. After blue there's green, seen often next to black; there's more gold than silver, more red than pink; yellow comes sometimes unexpected. It's the palette of a forested road trip, the destination a lake. You swim in this thing. I'd add another word, if I could make one up: surfascistic. It will not let you drown.

Maggie Nelson made a whole book, of something like poetry, about blue. Of course the blue is about other things: sex, love, lessening.

Nelson:

"Goethe describes blue as a lively color, but one devoid of gladness. 'It may be said to disturb rather than enliven.' Is to be in love with blue, then, to be in love with a disturbance? Or is the love itself the disturbance? And what kind of madness is it anyway, to be in love with something constitutionally incapable of loving you back?"

But for years I'd been used to madness and to a state of longing and could more easily reconcile that than straight desire. I'd been infatuated with the bluest-eyed boys. Finally, one of them had been good, very good, and I'd quit him after less than a year because I didn't want—I didn't know. In the summer we drove. We lived, like Salter's lovers, "in Levi's and sunlight," and lived apart: He in Toronto, me in New York. Like Salter's lovers, too, we'd never make it all the way to living here, in America, together. I guess that's what I knew. I would not let a year of happiness turn to one of ash. And I was heartbroken, but for that I found I was prepared. I was less prepared to be in love again. I was and am in New York and what did Vivian Gornick say? I'd rather leave a man than leave New York. No, it wasn't Gornick who said that, although I'm sure she would mean it. Susan Miller said that. Queen of horoscopes, she'd understand about the Salter. In any case: I was ready for heartbreaks, one after the other, crystals slipping off a string. I wasn't ready to be held tight. I didn't think.

When everything in *A Sport* I loved most was underlined, and when I could breathe again and get up, I put on a cheap black slip and Converse and a varsity jacket and Nancy Sinatra in my headphones and went to this guy's. I didn't text him. It was like elementary school. I just rang the doorbell and when he didn't answer I rang again and then I snuck in behind someone with a dog and left the book at his door. When I was at the end of the street, he texted. I went back. I was happy, wearing less makeup than usual, a little tanned.

"I'm sorry I'm such a freak," I said.

He said I wasn't. He glanced at the inscription, which told him, precisely, nothing but what day it was. Then he held me like he knew I would leave, but I didn't want to, and I wasn't sure what to do about it except kiss his neck 'til there was nothing else we could do.

Gornick reviewed Salter's latest, *All That Is*, in *Bookforum*. She spent much of her essay talking about *A Sport* and the sex in it, calling it "mythic" in a way that implies not "unreal," but "untrue." Which is wrong. I'm inclined to side with smart, disaffected bitches versus old established men, but I know from many-splendoured experience that Salter isn't making this

After black and white and dark and pale—almost nothing is grey in *A Sport*; it's all soft, flashing chiaroscuro—the colour of most things is blue. Carpet, the car Dean drives, and the sky, of course, but also things that don't have to have a colour, like cities. Light is blue. Flesh is blue.

shit up. Gornick notes that Dean is always entering Anne-Marie from behind. First, that doesn't mean fuck-all about a relationship between two people. Secondly, it's incorrect. The lovers fuck in every single, every last position. Some are less picturesque. Sometimes her breath rots, or his middle softens, or she is distant, or he's repulsed, but always they find each other naked. *A Sport* has that Fitzgeraldian diamond quality, but in sum it's not nearly as clean or improbably beautiful as Gornick, and other critics, think. It's only that if you describe light as well as Salter does, you can also describe dust and it'll glitter.

After it I took a picture of him in the cream-curtained sun, with a cigarette, more naked because he wasn't wearing a hat and he always wears a hat than because he wasn't clothed. It was a picture of a lover, but not mine, and I think it made him laugh but not out loud. I had never taken a photograph of him naked. I would never take one again; I knew that, or I wouldn't have taken it at all.

"I am creating him out of my own inadequacies, you must remember that," says Salter's narrator, to whom Dean is as mythic and infuriating as Angela is to Clarice Lispector's male alter ego in her last, consummate novel, *A Breath of Life*. "I am afraid of him, of all men who are successful in love."

I did remember that, later, when I saw how this guy looked at me from the photo. It was unlike how he had looked at me in life, and not at all unlike how he looked to other girls. Well, anyway: Photographs become images, and images get discoloured in time.

Two weeks later I walked away, and in two more weeks I would spend twenty minutes or more telling this guy who wanted me to watch him do things why I was his friend, but we could not be lovers, but I loved him, expecting not to be understood. Why weren't there synonyms. It was impossible. I just wanted to say finish that fucking novel. If there are no synonyms for love, that's why Salter has similes. Plus, I know you read the inscription and I know the postscript said I'm sorry, I should have done this in pencil, and I should have, but also you should just finish the book. One, it's not that long. Two, you would be sad, and being sad is more accurate than being sorry. It really is.

Sarah Nicole Prickett lives in New York, where she is the editor of ADULT *Magazine, a contributing editor at* The New Inquiry, *and a regular contributor to* Hazlitt. *Her moon sign is Aquarius. She is never bored.*

Fire in the Unnameable Country

Ghalib Islam

> *Fire in the Unnameable Country* begins high in the sky, as a boy is born on a flying carpet thousands of feet above an obscure land—a land whose leader records the contents of his citizens' minds onto magnetic tape reels for archival storage. Later, as the Unnameable Country collapses into disarray around him, the boy begins a rambling, hypnotic epistle, where, interspersed with accounts of terrorist attacks and the outbreak of a mysterious epidemic, he invokes the memories of generations past to expose the root of the current crisis. The following is an excerpt from the forthcoming novel to be published by Hamish Hamilton.

The universe is shaking. All the light enters the world in a great breath and I am asleep. What a shame.

Shiver and rumble walls, screaming sirens water on fire. Shaken tenements and Endless Movie Studio sets, loosened ceiling tiles across the unnameable country. Flakes of ceilings fell on faces. Children woke screaming from death in dreams. From cities like Victoria and La Maga, located as far away as along the coast of the Gulf of Eden, reports came in claiming reverberations for long hours afterwards, saying neighbourhoods had burned, glass shop doors had shattered without explanation, and young ruffians were dancing steps, loot in hand. My mother heard it first: Hours earlier, Nasiruddin Khan's nameless rebels had attacked the great Peacock Palace, long transformed from slaver John Quincy's place of residence governance acquisition and spidersilk manufacture into a cultural heritage site and wax museum.

The rebels were the bad guys, by the way, scowling, mean, rag-tag ragamuffins, poor in dress and impoverished in spirit, known to kick cats and eat dogs, and they were the ones that had attacked the Peacock Palace. The American occupation army, meanwhile, were the good guys as per studio scripts, protected residents with big bad guns, provided security for their own good,

were generous, doled out sweets to adoring crowds, and weaved knowledgably through the streets of a ubiquitous cinematic production that had transformed our unnameable nation into segmented terrains connected thematically by mirrors.

Reports indicated Victoria would be the next subject of spontaneous fire and unrest, and residents there were already packing bags and leaving their homes for the hinterland, for the hills, for countries with names. In Conception, my mother heard the radio mumble something about ongoing clashes between American forces and urban goondas and troublemakers, heard the announcer whisper to co-host oh yeah they came in choppers by air and in Jeeps with fishglitter cannons in sunlight mounted shots and pulverized scream and glass, heard them provide no reasons for the spontaneous flames is what I mean, sighed yet another fire, luckily her store had been spared. She rubbed her pregnant balloon belly before waddling to the front of her hosiery shop's entrance where neighbourhood ladies sat eating sharing shelled peanuts loud talking about the arrival of a certain Alauddin, the magician, about his rug. Who was Alauddin and what did they say about Alauddin's magic carpet. She was curious about the chatter outside her door, though she had heard them speak of him many times.

It was said that a certain Alauddin, a magician who had made a modest income once upon a time in English music halls performing sleight of hand routines, who had served in Alexandria in the British Army during the Second World War, who had died two inglorious deaths, first by dysentery and then murdered after quarrelling with an army sergeant over a woman before returning to life while floating down the Suez Canal, who had been picked up by a merchant marine vessel, migrated by the luck of his teethskin to California where he began to play small parts in Hollywood, who had wound up years later in Iraq from where he had just fled the Baathist regime for tax evasion, this selfsame Alauddin with a single name, had flown to our unnameable country in the dead of night about a month earlier by flying carpet and was now offering rides daily on his fabled machine.

To prove the verity of his craft, the magician described to citizens their country from the air exactly as it was, claiming he had seen it only while flying on his patterned peagreen carpet, which seemed more old than majestic, is actually ancient, he declared, from the century of Haroun al-Rashid, and which he claimed worked only by his direction. All this was true: He hovered several feet off the ground, rose twelve feet in the air, and when others tried to operate it similarly, the rug was unresponsive until Alauddin uttered some inscrutable open sesame words which were once commonly understood, and clapped twice.

Nasiruddin Khan, enthused by descriptions of Alauddin by the nameless rebels positioned against the occupying American troops/Nasiruddin who: Nasiruddin son of Joshimuddin Khan, owner of the largest spidersilk fields in our country in the early 1900s, Nasiruddin owner of spidersilk factories that produced soft cloth light to lift but impenetrable to arrows, beautiful spidersilk that drove a century of fashion and brought the late-slaving British and later invaders, the Americans who still remain, Nasiruddin who later included pop manufacture—Capsicum Cola, Valampuri Coke, Mirror Water—to his productions, was the primary advocate of rebellion against The Mirror, the Hollywood enterprise that began before Hedayat was even seed-egg and swept up the entire country in a maze of scaffolding and unfinished construction and two-dimensional houses, your nation for a movie set, would you have this, Nasiruddin Khan ridiculed, as we watched the region turn to mist.

Nasiruddin Khan, enthused by the information that among the magician's past exploits was his disappearance of Alexandria during the Second World War, thereby saving it from bomb attacks, thought of Alauddin as potentially useful to the rebellion but wanted to wait until proven he was not an American operative.

Watch him for now, he told his men. So for several months, Alauddin's rug becomes a household name, and his success invites other, less talented magicians, some capable of twisting wooden staffs into snakes, others lesser talented and repeating old rabbit-and-hat tricks, as the miracle of flight remains in Alauddin's grasp alone, since only he is able, with the magic carpet, to recreate the scintillating effect of the Maroon slave Amun's flight from the unnameable country and his perforation of the atmosphere through his calculated eviction by the colonial authorities at the dawn of our story elaborated elsewhere.

At street level, our city La Maga has become the ruins of a movie set, so Alauddin sets to work at sundown on the rooftop of the hotel where he stays, and watch: Already they're stretching from outside hotel doors through first level corridors up five flights of stairs to the rooftop where waiters serve patrons lined up to raised platform for rug and flight show.

For the price of an intracity bus fare, he takes up grown women, men, screaming children who cover their eyes as they climb above the clouds and dare not look as the ground becomes an encyclopedia map. How high, he asks each person, informing that after a certain distance from the earth you feel no fear because it no longer seems real.

Given his natural charisma as well as the fact that his carpet is potentially capable of freeing people from the checkpoints of La Maga and throughout

the unnameable country, he quickly becomes a threat to the occupying army, under whose hire it becomes clear Alauddin is not serving. At first they try poisoning him, which fails, since his first death from dysentery inoculated him against all attacks on the gastrointestinal. The sniper's bullet fired from a higher nearby rooftop at dusk when Alauddin is taking customers up into the sky misses the mark not once but four times as if the projectiles simply disappear before reaching their target. The operative responsible for strangulating the magician while he is bathing slips on a slight pool of water and lands badly on his neck, remains paralyzed for life, and Nasiruddin Khan denies the coincidental possibility of all these events and realizes Alauddin the Magician is meant to serve the cause of resistance.

In the small flat above the hosiery shop, the news of the flying rug excites even my world-weary Aunt Chaya, who has cut all ties with the world in permanent convalescence and decided to remain bitter against her sister, though Reshma has no interest in her German heart palpitation/her romantic interest, I mean and as I will later reveal fully. Alauddin briefly unites the sisters before Reshma's scheduled departure to Berlin to study at an art academy. Our whole family, including yours truly, Hedayatesque, swimming fetal, shuttles to the hotel and lines up to test-fly the rug.

Evening, folks, only three at a time, Alauddin's young assistant directs my mother and sisters forward, leaving my father grounded. I don't mind, he shrugs under the shawl he has brought for chills, latest symptom of his curious illness.

Are you sure, my mother takes a step backward, but Reshma grabs her arm. We'll only be a minute, Mamun, says my aunt.

The signal of my arrival can be described this way: High high in the air, my mother is narrating aloud with eyes closed as her sisters shout, hold hands, as Alauddin directs the sights from the distant horizon Gulf of Eden backwards, and my mother tells the story already once upon a time in her mind though not yet distant past, once upon a time, your father and I met in a cemetery crowded with cirrus clouds, she tells, as the thrill of flight pushes me curious towards the world, down through the birth canal as the carpet rises, and in my mother's shock a scream flies eyes like butterfly wings flutter. I am almost here. Like death, birth is unexpected.

Ghalib Islam was born in Bangladesh and immigrated to Canada at age seven. He has a B.A. in political science from McMaster University, where he focused on international relations. He is also a graduate of the University of Toronto's creative writing M.A. program, where he studied under Margaret Atwood.

A Few Things
I Know About Monique

Christopher Frey

An excerpt from Broken Atlas, *a book of reportage on the last decade of globalization.*

I was in Accra, alternating between palm wine and beer at a canopied drinking spot on Danquah Circle, the terminus of the city's high street, watching that evenings' arrival of them they called the "cash and carry girls." They came in packs, aloft on high heels, striding by the trinket vendors, the fruit sellers squatting beside their perfect pyramids of mangoes and oranges, past the serene-looking man grilling chicken gizzards. They were like a phenomenon of the local weather, or the ocean tides, the trebly, hectoring sound of their approach reliably signalling a change in the troposphere. Perfume melted into gusts of acrid offal smoke. Buttery legs scissored through the scattershot of car headlights. They wore cheeks, brows, and lashes painted in novel colour combinations, flags for nations not yet invented. But mostly they came from Liberia, Togo, Sierra Leone, and Nigeria.

You could count on seeing them almost every night, drawn by Macumba Discotheque, a louche dance club/pick-up joint where every night was ladies' night. The action usually spilled over to the nearby jumble of open-air, curbside bars where an anthropologist friend named Girish and I would sometimes meet. The goings-on here were always good entertainment. There was a lovely style with which the ladies ganged up on their prey, catching a fellow while he was otherwise unawares, say, buying cigarettes at a stall, and spinning him into their bosomy midst like he was a bird with its wings pinned back. Then working him over with their competing menus of priapic diversions.

As in any proper cabaret show we spectators could count on being recruited into the act. The performers sat at our table without being asked, the absence of women being invitation enough. *How is it you boys are alone?* They

demanded beers on our tab and edged their chairs in close, devising plans for the evening. Snubbing them elicited a cannonade of insults. The typical sort affirming that we were not men after all, just stupid goats. And worst of all, for a couple of foreigners, probably poor.

We hardly noticed Monique at first. But there she was, having already staked herself a spot at the table, demurely listening in on our conversation, Girish possibly on about the social dynamics of Pentecostalism in Ghana, or the complaints (probably justified) anthropologists often have with journalists. By comparison, there was something almost shy about Monique that disposed us to her company. Unlike the others, she waited for us to offer her a beer.

In the unlit spot where we sat Monique looked attractive, with hair extensions braided into ringlets of red, black, and gold that she brushed away from her eyes when she laughed or had something to say. She drank Guinness from the bottle, each sip showing off the gap between her two front teeth.

Monique was Nigerian, twenty-six, and a cross-border trader. She came from a family of traders—not market people, but wholesalers and middlemen, long-distance buyers who roamed the Gulf of Guinea coast. They had cut a trusted route, a geography of arbitrage, moving as far north as Freetown, down through Abidjan, Accra, Lomé, Cotonou, and points in between, looking for goods to offload in Lagos. They had been "into everything," she said, but for now she was mostly hustling second-hand clothes, shoes, sometimes lingerie, and liquor. The entire family was peripatetic: her mother was leaving Abidjan for Lagos tomorrow; Monique had a four-year-old daughter named Miracle who was temporarily staying with friends in Togo; as for her father, she said, "Oh, he is probably somewhere but we don't know where that is." He had left the family for another woman. Monique's sister was on a bus bound for Accra and Monique expected to see her in a few days.

It was buying and selling clothes that interested Monique most, because she believed she had an eye for fashion, and might one day parlay that into a more substantial business—a graduation from the informal to the formal economy. She liked all the travel and the contacts it made her, but she also dreamed of settling down and opening a shop back home, in the one-time coal town of Enugu in Nigeria's east. "A clothing boutique with the best styles from America and Europe," was how she described it. "Or at least the copies from China."

Monique stood up and modeled what she was wearing. Given her gentle demeanour, I was surprised at how sturdily built she was, that she did indeed look fit enough to be schlepping bales of goods hither and yon. She stuck out a hip to show off the pair of shiny, street-couture track pants she wore.

"Japanese label," she said. The ankles above her freshly scrubbed trainers had been itched raw.

When I asked how she fared from all this trading, whether it was a good business, she answered both yes and no. Yes, because it put money in her pocket today, and enough that she could go out in the city and enjoy herself. And enough that she knew she could eat tomorrow, and pay for the next bus ticket. But no, it wasn't enough either. Because there was still the future to worry about, what she called "the tomorrow after tomorrow," and that was always uncertain.

"There are too many risks," she said. "You can be cheated or you can be robbed. I try to not be cheated. But I can't do anything if I am robbed, like at gunpoint. That happens. It happened to me again last year. Five guys and me on the way to the bank."

Tonight Monique had money but she wouldn't be using it to pay for drinks. Maybe she wasn't the "cash and carry" sort, but she was hanging around Danquah Circle and putting herself at strangers' tables for a reason. Monique took the long view, cultivating friendships, sometimes sexual, with foreign men. There was, for example, the middle-aged Dutch journalist travelling around Ghana, and also a Dane relocated by his shipping company to Lagos. She reminisced most fondly for these. There had been proposals of marriage, but few were serious or promising enough to invest any hope in. She openly disliked African men, and was lukewarm on African-Americans, although it was a black Californian who came closest to marrying her—despite a wife he had no intention of divorcing back home.

As the night wore on the cabaret morphed into carnival. More white men arrived and began drinking, and the spaces between tables crammed with more gyrating ladies. The stereo system strained under the wall of sound, a jagged, bass-drenched adulteration of gangsta rap and West African high-life. A perspiring, podgy, 50-something German man dislodged himself from the crowd and began putting the make on Monique. As she waved him off he turned to me with a deformed grin and asked, "So have *you* been to Africa yet?" The German didn't go away and somehow we got to talking. Five years he had lived in Ghana, had a Ghanaian wife, two children. He loved it. He hated it. I asked what work he did.

"I import chainsaws," he said, and waited for my reaction. When I gave none, he reacted for me. "Oh, you are about to say, I am one of *those* people. The killers of the trees. Yes, it is true. I am destroying the rainforest!"

Soon enough the German's attention passed from me to a loud Ivorian woman with ocular albinism bee-lining his way.

Monique leaned forward and scratched at her ankles. Then she dispatched our Rastafarian server for another bottle of palm wine.

"If you come here every night," she said, "you will one day see the whole world pass by."

*

That first time I met her, Monique had avoided telling me she was Nigerian. "I come from Abidjan, in Côte D'Ivoire," she'd said when asked where she was from. But when I tried changing the conversation into French she refused. "English, darling, speak English. English is nicer." About Côte D'Ivoire I had many questions, mostly about the civil war. She could describe Abidjan and other Ivorian towns and assure me the country was now mostly peaceable, but her answers seemed conspicuously generic. It was only when I said that I was hoping to visit Nigeria next did she confess, actually, "That is where I am from, in the east, my people the Igbo live there." And: "If you go, you can hire me to take you. Nigeria is very dangerous, you will need my help." I asked her why she had lied about where she was from. After denying that she had lied at all, claiming that literally, she had come from Abidjan, in the sense that she had just been there prior to Accra, she allowed that being Nigerian is "no simple thing."

"People do not trust us. As Nigerians we have a very bad reputation."

In its own curious way, Nigeria's government could claim it was trying to address the situation. At that very moment its Information Ministry was in the process of designing a new public relations strategy, a rebranding that would months later arrive at the slogan, *Nigeria: Good People, Great Country!* (As if its people, merely good, could not quite live up to their nation's inherent greatness. Critics wondered whether more honestly addressing Nigeria's chronic troubles might itself go a long way to mending the nation's reputation in the eyes of foreign investors and tourists. The Minister of Information thought otherwise: "Nigeria cannot wait until its solved all its problems before addressing its image," she said, adding that a more positive representation might give Nigeria's citizens something better to aspire to.) I asked Monique what aspect of her country she felt was to blame for its notoriety. Government perfidy and corruption? Banditry in the Niger Delta? The urban maelstrom that is Lagos, which had recently topped a poll as the most dangerous city in the world? Or was it simply its legendary e-mail and fax scammers cheating people overseas out of their money?

"All of it, but mostly the scammers. When I meet a foreigner it is the one thing they know about Nigeria. We are a nation of cheaters. It is better to say

I come from somewhere else."

(Lo, such is one way, perhaps, of expressing what thinkers now like to call *the revenge of geography*, or, more poetically, *the impress of place*. As in *the world is NOT flat*, as if it ever were. Corrugated—*the world is corrugated*, that was how one thinker liked to put it.)

Whether she had to lie about being Nigerian or not, Monique travelled widely—as far north as Sierra Leone and as far south as Cameroon, rarely resting anywhere for more than a few weeks. Insofar as the unfettered circulation of goods and people across borders is the defining, if mythical, feature of a globalizing planet, West Africa has long been a microcosmic precursor to this frontier-less state of affairs. The Togolese politician Edem Kodjo once said of its borders, "the people trample them underfoot." It was a region, "across which, day by day, or night by night, people take themselves and their goods in more or less complete defiance of constitutional law."

Technology had certainly made Monique's world, in the socio-journalistic jargon, *flatter*—her trading easier and more profitable. She usually had three mobile phones on the go. While eating fried chicken one night at a restaurant in Accra, I watched as with greasy fingers she haggled into one phone over prices, and into another sought out when the latest bales of clothing were due to appear at a particular market, before arranging a bulk purchase through an intermediary. She sent and received images of product by SMS messaging. (The third phone seemed to be reserved for boyfriends.) Her world was demonstrably flatter also thanks to the removal of trade barriers and tariffs for secondhand American apparel, meaning West Africa was now awash in the stuff. For Monique, the blingier the cast-offs the better: she liked such ornamental details as the studded rainbow pattern on a pair of jeans, or the angel's wings stencilled on the back of a dress shirt.

There had been plans for Monique to visit a few of those boyfriends. The men had submitted the required letters of invitation and documents attesting they would cover the costs of her stay. But the immigration agents Monique hired turned out to be frauds—or so she claimed. Application fees were "lost," or the agents lied about the appointments they'd made for her with consular officials. Telling me this, Monique cursed the fact she is Nigerian, offering her suggestion for an alternate national slogan: "Only in Nigeria that they can do this to someone!" She did once manage to get into the Dutch consulate for a hearing, but that went badly; the officer, she said, was "verbally rough" with her, demanding answers she was unable to provide. She was deemed an immigration or security risk and her visa request was denied.

As Monique described it: Europe was now easier to reach, with several

flights a day from Lagos to London, Paris, or Amsterdam. But for her it was much more difficult to get into.

*

One day Monique was feeling bored and asked to tag along as I ran some errands about the city. Much of this time together was spent in a taxi, stranded in the traffic of Accra's metaphysically clogged Ring Road—an urban feature here that is as much traffic artery as moveable marketplace, with vendors of all ages swarming the halted cars and trucks, stoking needs the occupant knew not they had.

Some of the items for sale made sense: biscuits, water, newspapers, aspirins, fruit. Things that might help one survive the dreadful traffic. But one could stock a department store, albeit a very outdated one, with the spectrum of things available. Nail clippers, ladies' hosiery, and blow dryers. Cake molds, used wigs, bootleg DVDs (of course), Barbie dolls. Biblical commentaries, bicycle tire tubes, and traditional religious fetish items.

As a child growing up in Enugu, Monique had done the same, pushing her wares on passing cars and pedestrians. So when I said something, in my ignorance, about this scene maybe being a bit sad or pitiful, she scowled and lashed into me.

"Why you feel sad? It brings money to the family. You think you know what will sell but you never know what will sell. Sometimes you just try it to test. You get it on credit from your supplier, usually someone with a shop, or another trader. If nothing sells you return it. And you try something else or go back to what worked before. It's business. Don't be sad. Do not pity."

Monique was unmoved by the nattily-clothed kid at my window hawking sparkly Hello Kitty decals in between reedy asthmatic gasps made worse by the brown clouds of car exhaust he hurried through. Her brief lecture on local market economics over, Monique wouldn't talk to me for a while. Not until the traffic started moving again.

Christopher Frey is the Editor-in-chief of Hazlitt. *The preceding is an excerpt from the first chapter of* Broken Atlas.

Nessie Wants to Watch Herself Doing It

Patricia Lockwood

Doing what, I don't know, being alive. The green
of her is a scum on the surface, she would like
to look at herself. Should I have a memory?
she wonders. Of mother washing my frogskin
in muddy water? I do not have that memory.
My near-transparent frogskin? Mother washing
it with mud to keep it visible? I do not have that
memory, almost, almost. Warmblooded though
she knows for a fact, and spontaneously generated
from the sun on stone, and 100 vertebrae in every
wave of the lake, as 100 vertebrae in every wave
of her. All of her meat blue rare blue rare, a spot
on her neck that would drive her wild if anyone ever
touched it, and the tip of her tail ends with -ness and
-less. So far all she knows of the alphabet is signs
that say NO SWIMMING.

 So far all she knows is her whereabouts.
Has great HATRED for the parochial, does the liver
of the lake. Would like to go to universe ... al ... ity?

 She has heard there is a good one in Germany.
They stay up all night drinking some black sludge,
and grow long beards rather than look at them-
selves, and do thought experiments like: if I am not
in Scotland, does Scotland even exist? What do I look
like when no one is looking? She would listen to them
just as hard as she could with the mud-sucking holes
in her head – and they, she thinks, would listen back,
with their ears so regularly described as seashell.

The half of her that is underwater would like to be under a desk, the head of her that is underwater would like to be fully immersed.
 I will be different there, she thinks, with a powerful wake ahead of me. When will the thinkers come for me. Visited only here by believers. Is so deep-sea-sick of believers. When will the thinkers come for me here, where the green stretches out before me, and I am my own front lawn. The green is a reflective green, a green in the juicy shadows of leaves – a bosky even green – a word I will learn to use, and use without self-consciousness, when at last I go to Germany. I have holed myself away here, sometimes I am not here at all, and I feel like the nice clean hole in the leaf
 and the magnifying glass above me. She looks to the believers on the shore. A picture
 it would last longer! shouts Nessie. Does NOT believe photography can rise to the level of art, no matter how much rain falls in it, as levels of the lake they rose to art when Nessie dipped her body in it. Nessie wants to watch herself doing it. Doing what, I don't know, being alive. The lake bought one Nessie and brought her home. She almost died of loneliness until it gave her a mirror. The lake could be a mirror, thinks Nessie. Would be perfectly
 still if I weren't in it.

Patricia Lockwood's poems have appeared in The New Yorker, The London Review of Books, Tin House, *and* Poetry. *She is the author of* Balloon Pop Outlaw Black *and* Motherland Fatherland Homelandsexuals.

Why We Should Treat Poetry Like Painting

Linda Besner

The case for making contemporary poetry accessible to a wider public by putting it in museums and galleries.

PHOTOGRAPHY BY NADIA BELERIQUE

Linda Besner

I'm a poet, which means that when I'm not wishing I were a musician, I'm wishing I were a painter. There are lots of reasons to be jealous of painters. As a rule, people like them better than poets, and give them more money for what they make. Near my house, there's an old building that someone told me used to be a bathtub factory but that is now divided into lofts. Most of them are apartments, but on the bottom floor there are several being used as artist studios. When I walk by, sometimes one of the blacked-out industrial-size windows is cracked open and I can see in to the exciting mess of paint and electrical cable and dirty brushes and analog recording equipment and ladders and newspapers. It's like a brain full of vivid ideas splattered onto the physical world. My workspace, which is also my living room and kitchen, is on a bottom floor, too, but when you look in the window you just see a table with papers on it, and pens, and a few library books. Two dirty handkerchiefs draped over the back of the extra chair.

But mostly what I envy painters for is art galleries. Just walking into an art gallery gives me a feeling of uplift. I love libraries too, but the feeling in a library is that you will paw around ferreting out information, whereas in a gallery the feeling is that enlightenment will come to you. You don't have to know anything when you get there. You just check your coat, mash the clip-on tag to your collar, and trust that whatever you need to know will be explained as you go along.

This is why I propose that the best way to make contemporary poetry accessible to a wider public would be to put it in museums. To trot out an old saw: "Ut pictura poesis," Horace wrote in the first century BC. "As is painting so is poetry." This idea has been bandied about so much that scholars refer to it as u.p.p., and the question of whether poetry and painting do or should resemble each other has preoccupied artists from Titian to Wallace Stevens. These discussions, however, have primarily focused on artistic practice. What I mean isn't that poetry should have more visual elements or become more abstract or more representational or otherwise do what visual art does. What I mean is that I think people would like poetry better if there were somewhere they could go to look at it that had high ceilings and good lighting and curatorial text to explain things about the poems that might not be obvious.

At the Whitney Biennial last year, I saw a piece that looked a bit like a volleyball net made of spider-thread. It was called Sick Sic Six Sic ((Not)Moving): Seagullsssssssss ssssssssssssssssss, 2018, and it took up the whole length of a small room. I stood looking at it for a minute, and when I walked over to read the curatorial text I learned that the artist, Cameron Crawford, made the piece in response to the deaths of six people close to him. It didn't explain everything about the artwork (why seagulls?) but it gave me a place to start thinking about it.

A poet may also have an experience in the world—a personal, emotional experience, or an intellectual or visual one—and make an artwork that does not overtly describe or explain the original experience but builds on it instead. At public readings, poets often tell a story about their poem before they read it. Sometimes it's as simple as, "Cowbirds lay their eggs in another bird's nest and trick the other bird into taking care of them."

Sometimes it's as complex as, "You know when someone is explaining the special theory of relativity and they give that example of the guy in a speeding train and the other guy standing on the platform watching the train pass him by? I always feel bad for that guy, so this poem is from his point of view." In public consumption of visual art, we have a tradition of mediated experience; we expect there to be context not literally communicated by the artwork, and we look to the curatorial text to provide political, biographical, or art historical commentary that might help us to appreciate what we're seeing. Why not for poetry, too?

Perhaps because poetry is art made of words rather than pictures, readers expect it to communicate more directly. And certainly, some poems are fairly straightforward, in the same way that some paintings are clearly of horses, so that even the title "Horses" is unnecessary. But some poems would certainly gain aesthetically if they were freed from the burden of explanation. Poets themselves, I find, can be resistant to the idea of including notes or epigraphs, feeling that a poem should be self-contained and include all the necessary information. There are plenty of poets who neither provide notes nor contort their poems into self-explanatory shapes—these are some of my favourites, but I have to read them with one eye on the poem and one eye on Google. Who's Count Westwest? What's nanofluff? Who's Joe Sakic? Curatorial text that takes care of some of these immediate questions, and that also provides some interpretative remarks about the poem and how it fits into the poetic tradition, might help new readers

I would love it if all major cities had a poetry museum, where you could go for a visit dressed in your best all-black clothes. The poems would be widely spaced on clean white walls, big enough for five people at once to stand in front of and read.

appreciate what they're looking at.

Then there's the physical experience of wandering around a gallery. In an article published in the International Journal of Tourism Research in 2009, Charles McIntyre, a professor at Bournemouth University in the UK, conducts a study on why people go to museums and what kind of experience they hope to have there. He finds that museum visitors are "involved in a bid to escape the everyday ennui of modernist and post-modernist mass production, de-authentification of lifestyles and loss of an authentically meaningful sense of self." Citing museumgoers interviewed in his study, McIntyre goes on: "The area of discovery ultimately being sought was within their self. This was to be achieved via imaginative interaction with the minds of others as exemplified by the exhibits and their environment." McIntyre uses the phrase "time and space dreamers" to describe the imaginative freedom people achieve inside museums and galleries.

Looking at Marie Antoinette's hairbrush makes me hear the people shouting

at the base of the guillotine, and Frida Kahlo's paintings give me the feeling of being out in bright sunlight. In the same way, Irish writer Paul Muldoon's "The Treaty" makes me feel woolly and tidy and sort of damp: "My grandfather Frank Regan, cross-shanked, his shoulders in a moult,/ steadies the buff/ of his underparts against the ledge of the chimney bluff/ of the mud-walled house in Cullenramer." With many of my favourite poets, though, as with much contemporary art, the sensation is of a skimming, airy release from space and time. The dreaminess of galleries is in the visitor's liberty to move from one immersive, transporting experience to another with plenty of gaps and white space in between for associative thought.

I would love it if all major cities had a poetry museum, where you could go for a visit dressed up in your best all-black clothes. The poems would be widely spaced on clean white walls, big enough for four or five people at once to stand in front of them and read. You could go there on dates for the free Tuesday nights, and you could take your parents there when they came to visit. There would be architecturally remarkable staircases and third-floor cafés where you could eat arugula salads. You could wander from poem to poem, pressing buttons on your headset to hear a curator with a British accent talk about the poet's life and the political situation where they live and the echoes of other poets' work in the poem you're looking at. There would be rooms representing various strands of poetic practice, and when you travelled to other countries and visited their poetry museums, you could learn about their major poets, past and present, in one pleasant afternoon. You could buy books and posters in the gift shops.

Perhaps where we've been going wrong in trying to bring poetry into the public sphere, with our programs for getting poems onto buses and recited in the streets, is in trying to make poetry part of "the everyday." Because many people are intimidated by poetry, these programs try to normalize poetry to make it seem less threatening. But one thing McIntyre's study suggests is that people want cultural experience to bring them out of the everyday. Why not accept the public perception of poetry as specialized and allusive and hard to understand—"high art," in other words—and set it in dedicated cultural spaces where viewers are provided with tools to enhance their enjoyment?

Frank O'Hara felt the same way I do. "I am not a painter," he wrote, "I am a poet./ Why? I think I would rather be/ a painter, but I am not." O'Hara fixed this problem by spending most of his time hanging around galleries. He worked his way up from postcard hawker to associate curator at MOMA, meanwhile wandering around on his lunch hour writing poems. This spring I was talking to a gallery owner at a New York art fair, and when he heard I was a poet he said, "Oh yeah? You know what my interest in poetry is? Zero!" This guy's life revolves around visual art, but poetry is so far outside his frame of reference it's as if the two have never occupied the same cultural space, or even adjacent rooms. Poetry and visual art should share a natural audience. Maybe a coat check would make all the difference.

Linda Besner is a Montreal-based poet, writer, and Hazlitt *regular contributor.*

2003-2013
Toronto • Mexico • Los Angeles

ARTS & CRAFTS

Independent Music, Made With Care

Fall 2013 Releases
Still Life Still • The Darcys • Deer Tick • Moby

@artsandcrafts • arts-craft.ca

Battling Bitterness with Bogeymen

Naomi Skwarna

George Saunders discusses his new short story collection, *Tenth of December*, the importance of public artists, and the possibility that fiction makes us better people.

ILLUSTRATION BY LOLA LANDEKIC

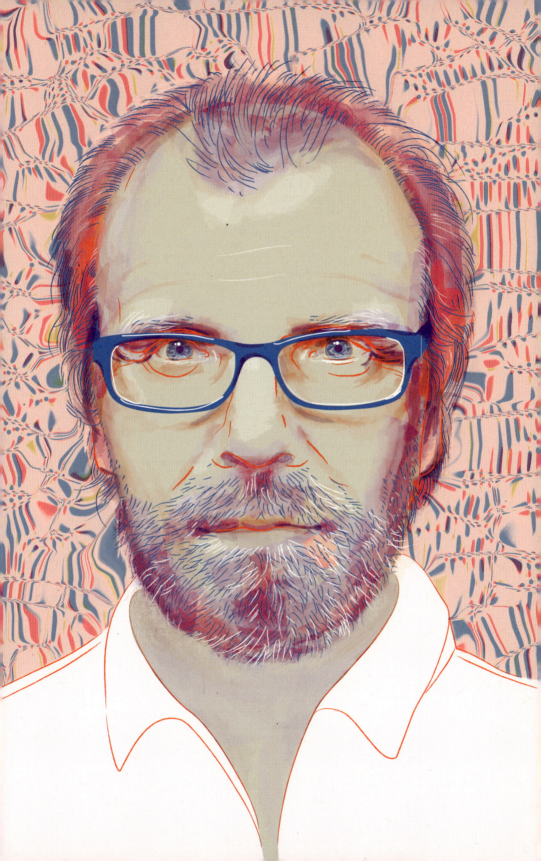

Naomi Skwarna

"Comedy may be a banquet," wrote John Lahr, "but without a killing there is no feast." George Saunders' books, like *CivilWarLand in Bad Decline* or *In Persuasion Nation*, are populated by misfits: an obese guy forced to bury a hastily murdered CEO in a pit of raccoon bones; a family of sad ghosts stuck reenacting their own murders. His characters delight even as they shift from high absurdity to shocking violence—the bodies piled so high you can barely reach the salt.

Throughout the bloodbaths, the slog of low-level yes-men and dilapidated theme parks, Saunders manages to produce chronicles of humility and grace. And laughs. And incisive explorations of good and evil.

It's hard to tell whether his latest collection, *Tenth of December*, is less gruesome than previous collections, or just better at hiding the stains. Take "Escape From Spiderhead," set in a world where certain privileged criminals serve their time by participating in dubious experiments in which they're administered drugs with names like Verbaluce™ and DarkenFloxx™. Or the title story, where a man dying of a brain tumour must force himself to act against his own hard-won selfishness. The violence is less exterior now, more rooted in emotion, and thus harder to laugh at.

A cheerful Saunders is thankful that we're talking on the phone, because he tells me that an interviewer once compared him to an affable Muppet. He admits to being a little more likely to write a story now where a baby falls off a cliff, but lands on a pillow instead of a spike. I feel mildly disappointed, in love as I am with the notion of a spiked baby. But hey, at least it still falls off a cliff.

Did life get very busy for you when *Tenth of December* was released?

I'm a little ashamed to say that I'm enjoying it all—it's really been a lot of fun. I've gotten to go on MSNBC and quote Terry Eagleton and Chekhov, it's a guilty pleasure. When I was a kid in the '70s, you had people like [Norman] Mailer on TV, so it's a weird thing that the writer has gotten a bit sidelined now.

What do you think having a more public community of writers would be like?

For any culture, to take the artist and set him aside is really a stupid move. Who steps into the breach? Talking heads, or professional entertainers. Suddenly, you start seeing the ship of state going a little off-course. In the case of [the US], off-course in the direction of aggression and paranoia. I'm not really sure that art is going to stop that, but [artists] belong in the conversation. My sense is that fiction is a great softener. It has the potential to make people slower to act and a little more thoughtful and engaged in the actual stuff of life. E.L. Doctorow and Tobias Wolff, or Alice Munro in Canada—you know that they're wise people; people who've spent hours and hours imagining the inner life of others, looking closely at the way that good and evil actually happen.

Your work has always struck me as being really aware of moral accountability. Reading *Tenth of December*, I kept noting in the margins how often you extend and highlight the moment of choice. But the stories aren't burdened with anger or condemnation. This is a long way of saying that this collection, especially the title story, made me feel like a better person.

Does fiction make us better people? I think it can, and I love the idea that it does, but when I'm writing, I put that notion aside. The great books that I've loved just sort of make you more alive. There's a dormant humanity in us and a piece of art can make that dormant thing come out a little bit more. Almost like a peacock tail that suddenly goes up for awhile ... and then it goes back down.

With really good fiction, you can live through it experimentally.

Yes, that's exactly right—like a scale model. As a writer, part of your job is to make that thought experiment inescapable. If the two of us enter this world together, my job is to go a couple of steps ahead and make sure there's no easy exit. That's a lot of what I do in revision, making sure that when you get to the place where I want you to feel the emotion, you are there without regret.

When did you start writing these stories?

It started for me sometime around 2006, but one of the stories, "Sticks," is really old. That's been around forever, and "Semplica-Girl Diaries," I actually had a first draft of that in '98. But most of the book started after *The Braindead Megaphone* [an essay collection], and sometime after that I stopped doing any other kind of writing than fiction.

"Sticks" is so bracing. I love the part where the narrator recognizes his own nascent meanness.

Isn't that what we all have to watch out for? I sometimes think that life on Earth is a battle against your own bitterness—trying to push it down and as long as you can.

All of your characters, every single one of them, are constantly in combat with their meanness, or their bitterness, or cowardice. Al, in "Al Roosten," or Eber and Robin in "Tenth of December."

As you get older, you have these moments of clarity where you see where all the nonsense in the world comes from, and you can also see that it's on a continuum with your experience. If you see someone doing something really awful, in history or across the street, it's interesting to think that with imagination, you could come to understand why they did it, without endorsing it. It's a scary way of looking at things, but invigorating.

In Joel Lovell's *New York Times Magazine* story about your work, there was a part in which you talked about discussing writing with David Foster Wallace, Jonathan Franzen, and Ben Marcus—the question of creating emotional writing, truthfully. Do you feel like you've come to understand how to deliver that in your own work?

No. I mean, yes and no. The subtext of all those conversations was that you have to make the fiction lively, it has to be new in some way. I found that the way I could get energy into my work is by being funny, a little irreverent, being fast, being a little bit pop culture-ish or something like that. That's how I got a first book out.

How do you keep making it new, story after story?

Say I want to keep that energy in my work and I want to make it more—fill in the blank. Accessible. Emotional. Whatever you want to call it. You're trying to move over there without leaving those initial virtues behind, because that's what keeps your reader engaged. That was true of Dave Wallace—in his case it was that high postmodern, cerebral, amazing intelligence that he had, and I think he was moving toward the same doorway again. He had to—you can't forget what got you invited to the party in the first place.

In your preface to the second edition of *CivilWarLand in Bad Decline*, you mention the pleasure of locating your stories in theme parks. Was that a way of evading your instincts, e.g. writing imitatively of Hemingway?

When you read writing about writing, one of the tacit assumptions is that the writer had an intention to do thing A, and she went out and did it, haha! Congratulations, victory. But in my experience it's more that you're just trying not to stink. You're trying to get your

!ndigo spotlight

An outstanding new read

Five Days at Memorial
by Sheri Fink

We all remember Hurricane Katrina. But what if you were there, working the flooded floors of a New Orleans hospital during those unimaginable days? Could you decide who was worth saving?

A true story: gripping, heartbreaking, and richly human.

After months of reading and debate, there's one thing our book buyers can agree on—you're going to love this book!

| !ndigo | Chapters | Coles | indigo.ca |

/chaptersindigo

Indigo, Chapters, Coles and indigo.ca are trade marks of Indigo Books & Music Inc.

prose to have something in it that compels the reader to keep listening. I found that if I put it in a theme park, it freed up a lot of my positive virtues. It was an accidental find, but it really changed everything for me. I didn't have any intention at the beginning of talking about American pop culture and Plato's Cave. There was no grand political intent. I was just trying to not stink.

Tenth of December feels like a departure from that. The stories are less fantastical or dystopian than some of your previous work.

As you get older, I think you want to get all the different valences of life into your work somehow, even if they're a little shrunken or distorted. For me, I'm now 54, my wife and I have been married 25 years, we have two wonderful daughters. It turns out life is more than just a dystopia. You look at a writer like Tolstoy or Alice Munro and they have three-dimensional representations of a happy life in their work, which is the hardest thing to do. That's an aspiration I have, to be able to represent all the different modes of being on Earth. A modest ambition.

When you look at it now, do you see an organizing principle in this collection?

When I read it the last time, I thought, well, it seems to be a lot about those occasions when human beings do good things. How does that happen? What are the contributing factors to somebody actually finding the wherewithal to do the right thing in a given situation?

That was what you observed reading it afterwards.

Yes. If I preconceive things then the worst thing happens. That is: the story is what you planned. That's a disappointment for everyone, because the reader is smart and a little ahead of you, even. So if the reader sees it coming and then it comes, the reader is rightfully disappointed. The only way you can have the proper relation of respect with your reader is to not be sure yourself of what's going to happen, what it means, or what you "want to say."

It's hard to imagine your work not requiring painstaking design. They have such mathematical plots, like "Escape from Spiderhead."

It is mathematically plotted, but if you give yourself enough time, that process happens one beat at a time. In "Spiderhead," I started with the idea that there's a drug that changes the way you talk, and then in the midst of doing that, it produces the next beat. And so you just keep doing that, and at some point you get off-target, and then what you do in the revisions is cut the false moves and return to the essential. The idea is that story begets story. If you have one convincing scene, it will tell you what the next scene needs to be in order to fully address the energy of the first.

Your writing frequently satirizes capitalist systems. By being a storyteller, do you feel like it's possible to avoid some of the drudgery that your characters are often trapped by?

One thing I've loved about being a writer is that it's one of the few areas in art—maybe along with being a poet or a painter—where you really don't need a lot of help to get it done. You don't need $100,000 worth of equipment, you don't need co-writers, you don't have any imperative to keep your ratings up, especially if you're teaching. There's nobody outside of your own bad instincts co-opting you or trying to get you to say something that isn't true or authentic. The culture needs a skeptical outside voice that doesn't have to speak the popular truth to have a platform. That's a really wonderful way to live.

Naomi Skwarna is a writer, theatre producer, and regular contributor to Hazlitt. *Her interviews have also appeared in* The Believer.

The Cyclist as Cannibal

Richard Poplak

The story of disgraced cyclist Lance Armstrong isn't just about the greatest doping conspiracy in sports history—it's about the nature of corruption. In this excerpt from *Braking Bad: Chasing Lance Armstrong and the Cancer of Corruption*, author Richard Poplak asks what kind of man is best fit to excel at the Tour de France.

PHOTOGRAPHY BY LORNE BRIDGMAN

Who rides?

Answer: Cannibals. People who eat people. Conversely: cannibals' victims, those eaten by people who eat people. For now, we must concentrate on asking why cycling, unique among sports, is made up of flesh eaters/dinner ingredients. Wayne Gretzky was called "The Great One."

Michael Jordan was "Air Jordan." Eddy Merckx, cycling's leading eminence?

"The Cannibal."

Cycling has always made mincemeat of men. At its inception, it was a working-class sport, indistinguishable from the farm or the factory in a rapidly industrializing Europe. Who rode? The poor, the unlucky,

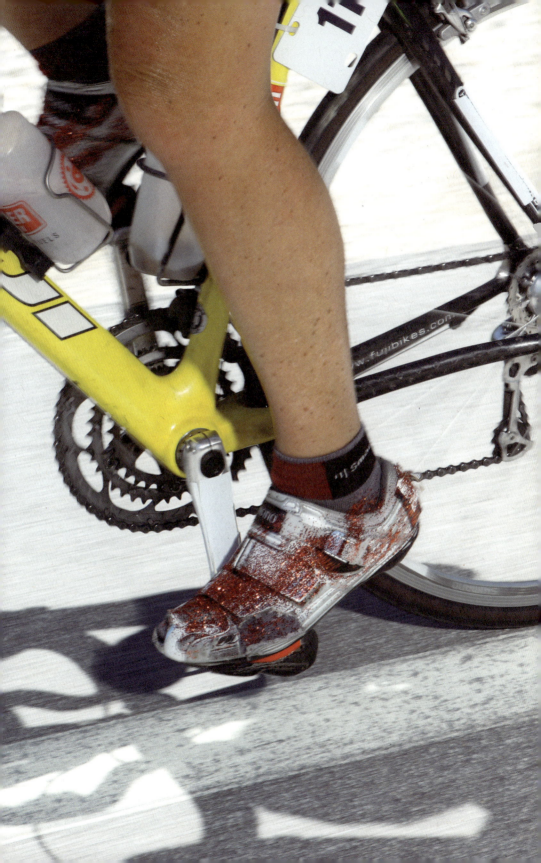

the daft, the ecstatically religious. *Forçats de la route,* "forced labourers of the road," insisted the Socialist firebrands who picketed in support of these maligned characters. The leftists didn't see sportsmen but rather *ouvriers de la pédale,* "pedal workers."

Cyclists understood themselves in a similar light. Wrote the Italian author Dino Buzzati, upon his retirement, "And without a number and jersey we, too, will sit on our doorstep, on these days in May and June, to watch other legs turning; no longer ours, though. And we will say: For us (thank heavens!), no more backbreaking exertion, dust, torment, oh, oh, and no more dysentery. We've had enough of that hellish life of a convict!"

The inaugural Tour de France, held in 1903, had a direct precursor in an automobile race called Paris–Madrid, which devolved from modernist panegyric to carnage in a matter of hours. People, livestock, dogs, all killed by the "folly of speed." The race was never repeated.

One month later, the Tour de France tore through the country with less gore and significantly more pageantry. Henri Desgrange, the editor-in-chief of the periodical *L'Auto* (and the Tour's founding director), promised that the contest would send "those tough, uncomplicated sowers of strength, the great professional roadsters," into the common Frenchman's imagination—more than that, past his front door. The peasant would never forget the cycling hero, contended Desgrange, "Because he will have seen him." Desgrange had invented the Grand Tour: there were no motor paces, the race was split into stages, and the fastest time overall, or the "general classification," earned the yellow jersey. The winner of the first race, Maurice Garin, was known as "the Little Chimney-Sweep"—when he was an infant, his father traded him for a wheel of cheese. He raced against Pothier the little butcher's boy, Dargassies the blacksmith, and Brange the barkeep. A coterie of working men, with soot-blackened fingers and hard peasant eyes. They set up shop in the French pantheon and refused to budge.

The author and humorist Judith Newman describes sportswriters as "fellows who don't just document the mildew and peeling paint on a boxing gym's walls but go on to liken it to the weeping of fetid tears over the tragedies they've seen" (which, come to think of it, reasonably sums up the conceit of this essay). In cycling's case, Ms. Newman is doubly correct, because Desgrange designed cycling to be written about in this way. An Italian journalist covering the 1949 Giro d'Italia portrayed Fausto Coppi as Achilles and his foe, Gino Bartali, as Hector. Roland Barthes, in a chapter in *Mythologies* entitled "The Tour de France as Epic," states that the Tour is a "unique fable" that "liberates French people." Grand Tours are described as "Homeric"; certainly, they are an "odyssey." A solo break is "Sisyphean." As Hugh Dauncey and Geoff Hare, two of the Tour de France's chroniclers, have pointed out, the race is "the non-religious equivalent of the medieval mystery play, defining (and redefining) the nature of masculinity, glory and heroism. It is at once both a secular and sacred experience."

Maybe. But Grand Tours, and cycle races in general, were from birth craven, commercial enterprises, engineered to sell the bourgeoisie on modernity's latest tricks. The sport has always been about

> I wonder whether Armstrong was bummed that "the Cannibal" had been snapped up as a sobriquet before he made the scene. No one ate people like Armstrong. He ate not just his opponents but the men on his teams. Churned through them. He made many careers, a huge caste of cronies. When he was done with them, they were put on the menu.

money. It's always been tied to newspaper sales (in the Tour's case, first *L'Auto* and now *L'Équipe*, whose circulation rises by a third during the race). From its first moment, racing required sponsors. Sponsors demanded results. Results were acquired through both ability and deception: during the 1904 Tour de France, the roads were lined with highwaymen, drive-by shooters, enraged gamblers, drunken mass murderers, and loose women—sleaze was rampant, cheating was de rigueur. It took the Super Bowl almost thirty years before Janet Jackson experienced a "wardrobe malfunction"; it took the Tour de France all of eleven months before the first breasts were bared.

Duelling tropes were established. Cyclists were either gods or bumpkins caught in the pincer grip of exploitation and corruption. It does seem almost too perfect that cycling's Grand Mufti, its Abraham, its Luke Skywalker, is the Belgian Eddy Merckx, son of a grocer, and a labourer of the road. "We were not rich," Merckx has said of his family. "We did not go to the Côte d'Azur or skiing. Our only vacation was to the North Sea. I had to pay for my bicycle every month, but we always had food."

Merckx acquired his nickname from his 12-year-old daughter. "Daddy, he's a cannibal," she warned a member of Merckx's Peugeot squad. The Cannibal, who dominated from the mid-'60s to the mid-'70s, is certainly the best cyclist of all time. But there are only minor and easily dismissed arguments to be made against this claim, according him the status of Greatest Athlete of the Modern Era—in any sport, and by a long shot. Eddy was Michael Jordan if Jordan had Shaq's size; Wayne Gretzky if he was also Paul Coffey and Marty McSorley; John Elway if Elway was also the entire Broncos defensive line. He rode track, won the Classics and won all three major Grand Tours. He did so even though the (largely French) cycling establishment was against a Belgian picking off Tour de France victories. He was punched in the liver by a spectator during the '75 Tour and forced to abandon his attempt at a sixth title.

Eddy Merckx is the Ur-cyclist, and thus the Ur-athlete. But who is he? I met him once at a trade show, we shook hands, he was gone in an instant. I tried to get a whiff of his limitless power—I literally tried to smell him, to huff in his pheromones, to see if I could unlock his mystery via his scent. I have watched almost every second of Merckx committed to film, and there was no sense of the

SCOTIABANK GILLER PRIZE 20

The first word in fiction for **twenty years**

2012

2009

2008

2007

2006

2005

2004

2003

2000

2000

1998

1997

1996

1995

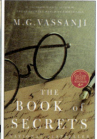
1994

PENGUIN RANDOM HOUSE

athlete in the man, no hint in how he carried himself of who he once was. To meet Kobe Bryant or Cristiano Ronaldo is to meet athletes who absorb adulation, who glow from it. They take off their sunglasses and you think, nice move. Merckx looked like an aging banker, and the love just bounced off him and fizzled into dead energy at his feet.

He is a terrible interview who has never been profiled satisfactorily, mostly because he keeps himself tightly buttoned. One will get more answers interviewing Eddy's bicycle. He has much to hide—he is no doubt reluctant to talk about poppers and speed and other, earlier, tools of the trade, some for which he was disqualified. "Products that made you a little less tired," as Merckx has described them. A distinction, he insists, from products that "make you better."

Merckx rode with his head off to the side like a trotting hound, and always looked like he was losing, even when the rest of the field was eight miles back. He is a big man, too well built for cycling. He had no *souplesse*—suppleness, the ideal of riding with élan, of making hell look effortless. *Souplesse* is not a technique, it is an attitude. (Lance Armstrong's lack of it partly explains the early French revulsion toward him.) If you want an example of souplesse, or of the noble officer class that it is meant to emulate, watch Pierre Fresnay's performance as Captain de Boeldieu in Jean Renoir's *Grand Illusion*. He never broke a sweat, never looked concerned, and died like a gentleman.

Cycling imposed aristocratic mores on working-class boys, which is not to say that every cyclist was working class—five-time Tour winner Jacques Anquetil rode with *souplesse* because he was born

a Sun King. Merckx, however, ate people. You can see it in old race footage: he devoured them. I don't want to overstate my own race credentials, but once or twice, I've done the same thing, felt the man beside me break, felt as if I'd stripped the flesh from his bones. I suspect that the feeling has its roots in ancient battle rituals—nothing says victory better than ripping out and consuming the warm heart of an enemy.

The impulse in any sport is not only to beat those alongside you on the start line but to erase the records of previous generations. When Lance Armstrong was dying of cancer in a Texas hospital, the Cannibal paid a visit. They've always admired each other, despite their manifold dissimilarities. I do sometimes wonder, though, whether Armstrong was bummed that "the Cannibal" had been snapped up as a sobriquet before he made the scene. No one ate people like Armstrong. He ate not just his opponents but the men on his teams. Churned through them. He made many careers, be they fellow cyclists, doctors, sunglass manufacturers, writers, lawyers, masseuses. A huge cast of cronies. When he was done with them, they were put on the menu. From 1998 to 2011, Armstrong fed and fed—the most significant gorging sports has ever known. By the time he was done, there was almost nothing left of the sport that made him, of the sport that Desgrange made, of the sport that Armstrong's voraciousness helped turned supernova.

Born in Johannesburg, South Africa, Richard Poplak is an award-winning author, journalist, and graphic novelist based in Toronto. He is author of the books The Sheikh's Batmobile *and* Ja, No, Man.

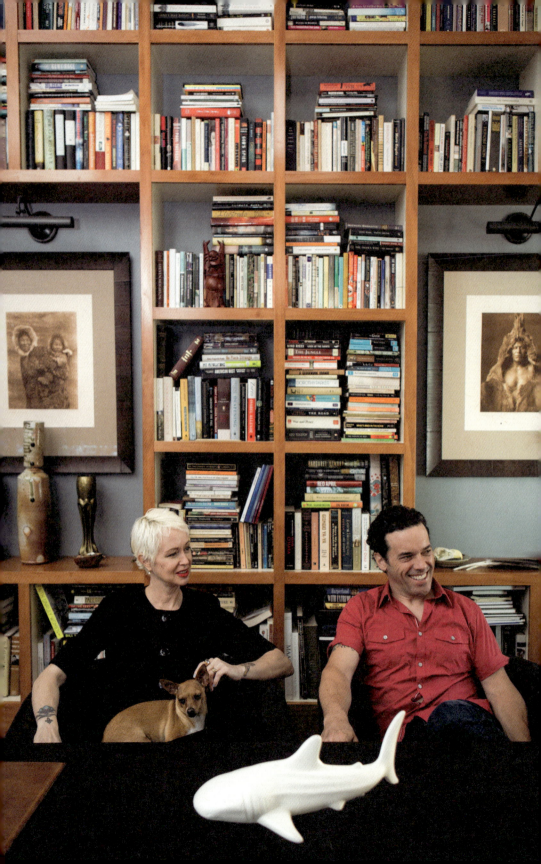

Shelf Esteem: Joseph and Amanda Boyden On the Corner

As told to Brett Michael Dykes

A regular look at the bookshelves of writers, editors, and other serious readers, in their own words.

PHOTOGRAPHY BY WILLIAM WIDMER

Joseph Boyden's books reside on a towering wall of shelves in the library of the New Orleans home he shares with his wife, Amanda Boyden (author of Babylon Rolling *and* Pretty Little Dirty*). Hazlitt dropped by their house—formerly a 19th century corner grocery store—shortly after Joseph's latest novel,* The Orenda, *was named to the longlist of this year's Giller Prize.*

On finding their new house
Amanda: You know, I've had a bad habit of online shopping. I don't like to go shopping in person and we were living Uptown just off Magazine Street and they had discovered termites in half of the building we were in. We had a two-story apartment and they had to remove an entire wall. So we were living with blue tarps for too many months in a row and I had a novel due, Joseph had a novel due, and we said, "Well maybe we should actually consider buying," so we met with a realtor. I went shopping around online and realized we couldn't afford to buy anything up over there. Joseph said, "Well, let's expand the search" and I saw this house, and the listing had coincidentally just been put up that day. I said, "Joseph, I think I found our house!" And it was the first and only house we ever looked at.

Joseph: Amanda actually found our dog online, too. We got our house online and our dog online... The house is an old corner grocery store, it was built over a hundred years ago.

Amanda: In 1897 or something like that.

Joseph: People still come by all the time and say that they remember coming in here when they were kids to get their chips and pop and such.

Amanda: It has such a good vibe. It's filled with people very often. We throw giant parties here.

Joseph: Yeah, it's a great house and our books are our children. I have a son from when I was younger— he's grown up now, he's 23—but Amanda and I never had children so we look at our books as our kids and we love to have great gatherings. We do huge crawfish boils in the spring. And actually for a Canadian I'm getting pretty good at boiling crawfish.

We love nothing more than to gather our writing students and our friends. Amanda and I are writers-in-residence at the University of New Orleans and we enjoy throwing great big welcoming parties. We just had one a couple of weeks ago for the new students in the MFA program and the house was packed. But it's a good house for that sort of thing because you can wander around everywhere and nothing is overly sacred with us.

On being New Orleans Saints fans and hosting game day parties
Joseph: We have huge Saints parties here. The one we had this past Sunday was much more intimate. We had about 25 good friends with us. We've had gatherings where we've had, like, 100 people come by. We have TVs going with the game on them throughout the house.

On the room that would become their library
Joseph: This room was just a big, giant empty room. We had a couple of big bookshelves and we didn't know where in

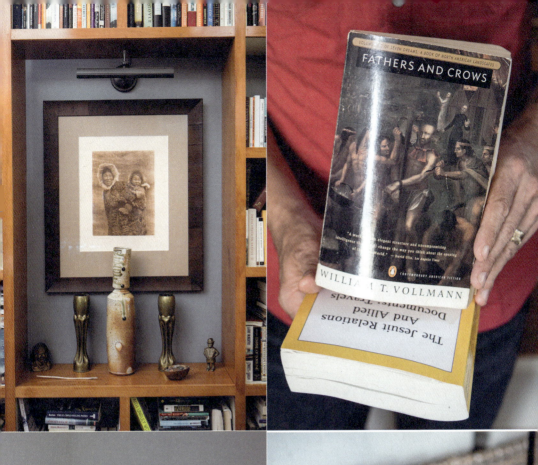

the house to put them and I said to Amanda, "Why don't we put them in here for now." And Amanda's light bulb went on and she said, "We've always wanted a library and this would make a good room for a library."

On books that influenced Joseph's new novel, *The Orenda*
Joseph: Oh, I've got all my research books. I have a research cubby for them.

Amanda: He has a cubby.

Joseph: *Children of Aataentsic* is one. This novel is about the mid-1600s in what is present day Canada. The Jesuits coming to bring Christianity to the heathens.

Research books were the big focus. There's not a ton of novels about that period. There's one novel called *Black Robe* by a guy named Brian Moore. It came out in the '80s and was a hit, but he got the native people really wrong in it and I wanted to correct that. I wanted to correct the history that I think he—you know, I don't like to speak ill of the dead, he's dead now—but I wanted to correct some of the misrepresentations of that novel.

On books that Joseph relied on for inspiration while writing *The Orenda*
Joseph: Yeah, *The Jesuit Relations* is one. The Jesuits kept records, like they kept diaries of their time in the wilderness and sent them back to France to their superiors. And so these are direct diaries I'm reading of the time period of their experiences with the Indians. And a great non-fiction book called *Champlain's Dream*.

Another book is called *Fathers and Crows* by William Vollmann. Do you know his work? He's been writing the history of the world through fiction and these giant tomes. He's a fascinating writer. *Fathers and Crows* had a big influence on me. It's very different.

On books and writers that played a part in them becoming a couple
Amanda: We had a lit class together in graduate school and the professor was talking about the three elements that we have at our disposal as writers. We have exposition or summary, we have scene, and we have dialogue. And that's all we get, right? We only have those three and she's asking people to give examples of different books that rely heavily on dialogue, for example, or scene. And nobody could come up with summary except for Joseph and me. We both raised our hands and said Robertson Davies at the exact same time. And I thought it was—

Joseph: He's a Canadian writer, but not obscure by any means. He's huge in Canada but in the States he wasn't as well known. So I was fascinated that Amanda knew who he was.

On books about or set in New Orleans that have influenced them
Joseph: *A Confederacy of Dunces*. I read it in graduate school and thought it was a hilarious and very strange story about a strange city. And then I read *The Moviegoer* and I'm not a big fan of that book.

Also, I was reading Richard Ford while he was living here. He was like the idol many young writers looked up to. He was this great American writer living here. This is such a writing city, you know.

On the books they're most likely to gift to other people

Amanda: I would start with Louise Erdrich's *The Round House*. I'd give almost anything of Margaret Atwood's.

Joseph: For younger students I still like to give them Jack Kerouac's *On the Road* just because I think it's a novel filled with such life and spirit. It's a hugely popular novel but not everyone likes that book. I also like Wells Tower, he's an amazing writer. Everyone's waiting for his novel. And Cormac McCarthy's *The Road*. I like a lot of his work. *All the Pretty Horses*.

On what books made them want to be writers
Joseph: When I was in grade six or so my older sisters brought home *The Outsiders* by S.E. Hinton. And they weren't reading it so I grabbed it and ate it up, and was blown away by the writing. That's when I knew that I wanted to pursue writing.

Amanda: I was reading a lot of collections of short stories, oddly they were sort of popular back in the late '80s and early '90s. I was bartending and waiting tables just to make ends meet. I don't remember many specific short story writers, but the one that sticks out most is Lorrie Moore. I just think she's fabulous and I thought, "I will never be that good. I will never be able to write like Lorrie Moore." She intimidated me into going into an MFA program, you know. But it was like the best sort of intimidation.

On career milestones
Joseph: I didn't write fiction until I moved to New Orleans. But then, when Amanda introduced me to Louise Erdrich, I realized that because we write from the same kind of place she was a great role model for me. And then I think probably my happiest moment as a new writer happened when my first novel, *Three Day Road*, came out and she was the first person to blurb it. I was like, "Wow!"

On writing together daily
Joseph: Amanda and I actually write sitting right across the table from each other. Amanda talks way more than I do.

Amanda: That's so not true. So not true.

Joseph: We'll stop and read sections of what we're working on to each other. We're very honest. My last novel was called *Through Black Spruce* and I finished a draft of it and I gave it to Amanda. It was a 500-page novel at that point. She read not even the first hundred pages, put it down, and said, "It's not working."

Amanda: I didn't say that. I did not say that!

Joseph: You did. [*Laughter*] She said, "I don't want to read on any more because I don't think it's there."

Amanda: I said I didn't think it was functioning the way it should just yet.

Joseph: Basically, she told me it's not there yet. And you have to do that. You have to be honest with each other but we'll also praise each other. She tells me that this new one is my best book.

Amanda: It's my favourite by far.

New Orleans-based Brett Michael Dykes is the Editor-in-Chief of Uproxx.com.

'I Was a Directionless Acid Freak Until I Found Cooking': Four Cookbook Authors Talk Shop

Meredith Erickson

Peter Meehan, Jennifer McLagan, Naomi Duguid, and moderator Meredith Erickson on annoying food trends, what makes a great cookbook, and how they really feel about following recipes.

Jennifer McLagan: author of three critically acclaimed books, *Bones*, *Fat*, and *Odd Bits*. She splits her time between Toronto and Paris.

Naomi Duguid: co-author of six globe-trotting, award-winning books, often referred to as a "culinary anthropologist." Her latest book, a solo venture, is *Burma: Rivers of Flavor*.

Peter Meehan: loveable New York-based author of *Momofuku* and the *Frankies Kitchen Companion and Cooking Manual*. He also edits a little magazine called *Lucky Peach*.

Meredith Erickson: co-author of *The Art of Living According to Joe Beef* and *Le Pigeon: Cooking at the Dirty Bird*. She splits her time between Montreal and London.

Meredith Erickson on the road in Oregon for the making of the Le Pigeon cookbook.

Meredith Erickson: Going back in time for a moment, what are some of your all-time favourite cookbooks, models of the genre that you keep coming back to?

Jennifer McLagan: Well, there's always a book you go back to, right? I tend to go to books that give me ideas, so I love Stephanie Alexander's *Cook's Companion*. Naomi and I were talking the other day about Patience Gray. Books that are not just recipe books, they're full of culture and history and tons of other ideas as well.

***Honey from a Weed* by Patience Gray is one of my all-time favourites.**

Naomi Duguid: I'd add to that Elizabeth Luard and her *European Peasant Cookery*. But I agree with what Jennifer said about staying away from cookbooks. I don't look at them much. The only time I follow a recipe is when I'm testing a recipe that I am developing. I don't otherwise, it just doesn't interest me. I think I'm just really bad at doing what I'm told, you know?

Jennifer: I feel the same way. I think I use cookbooks more as an idea point. I go, "Oh, look at that combination of foods, that's kind of interesting." Then I read the recipe and go and do whatever I want basically.

PHOTO BY DAVID REAMER

Meredith Erickson

Peter Meehan: I do cook from recipes, and if a recipe from a book doesn't work I just throw it out, or give it away, donate it. There are a lot of books, like *Honey From a Weed*, that are inspirational, the way we can write about and portray food. But the books that helped me learn how to cook and gave me an idea of how a cookbook should function were Paula Wolfert's *Couscous and Other Good Food from Morocco*, and *The Cooking of Southwest France*, and Marcella Hazan's *Essentials of Classic Italian Cooking*. I've cooked every recipe in those three books and I think that's how I learned to cook in my early 20s. Those books took me from barely having ever eaten duck to understanding how to butcher and process and use every part of it.

Those were my education. I dropped out of college and cooked my way through those books and now I've ended up here. I think those three are the most important books for me historically, even if I don't cook out of them as much anymore. When I was finished cooking something out of Paula's books I had learned it in my bones and I could make it without a recipe from that day forward. I think that's a more difficult thing to do than people give it credit for.

All of us write books that are a combination of prose narrative and recipe writing. Is there one you prefer over the other, or is it for the full package why you do what you do.

Naomi: It's a bit of everything, that's one of the great things about writing a cookbook—you have the choice of things to do. So if the narrative isn't going very well you can just put yourself back in the kitchen and work on the recipe and then come back to it. I was going to point out that those books that Peter was referring to, I think I'm correct in saying that they are free of photographs. I wish there were more books that had pages and not so much photography, but I don't think that's going to happen again. A lot of the books I love have no photographs in them at all.

Jennifer: Now they've created this kind of cookbook that is picture, recipe, picture, recipe, picture. It's like what we were saying before, if you try to write a recipe that runs across a double page spread or makes the reader turn the page over—the editors and the publishers get extremely nervous about that, like no one can turn a page in a cookbook.

Naomi: Peter, in *Lucky Peach* you guys don't necessarily have typical photographs when you publish recipes, and there's all those wonderful flow charts.

Peter: We find rules and break them for no reason other than they're there to be broken. One of the things we try to do is find new ways to reformat recipes, and we've already done that twice in the magazine. The exciting thing for [*Lucky Peach* co-editor] Chris Ying and I is when we talk about how we're writing and presenting recipes, and how people read them, relate to them, and cook from them. Being experimental with it. It helps we're not a recipe-driven publication. No one should buy *Lucky Peach* for the recipes.

**I'd like to talk about cookbooks as collaborations compared with ones you write alone. Peter, you've done it all, right? You've

worked one-on-one with David Chang of Momofuku, together with a group to make *Frankies Kitchen Companion and Cooking Manual*, and now it's more of a recurring team effort with the magazine *Lucky Peach*. Maybe for the few people who don't know *Lucky Peach*, you can first explain how that works and then talk about how you feel about collaboration.

Peter: *Lucky Peach* is a food magazine, kind of like all the other food magazines...
Naomi: Not at all. Come on, stop it...

Peter: ...with longer articles about eating snakes and camels. Collaboration is something I fell into because the economics of it made sense, with the people I knew in New York and the relationships I had, being broke and young. It's something I've done for the past few years because it's worked out that way, and I'm really proud of the books that I've done. But I've never done a book on my own, and I feel like that's something I really want to do and need to do, to go through that process.

It's not like the people I worked with were co-writing these books with me. They are essentially personalities and I am doing some manner of ghostwriting, as much as I hate to call it that. It's easier when you're working from an established framework of recipes and personalities, but I hope I've done interesting things with the people I've worked with.

The magazine is a completely different animal than doing a book, because it's a lot of different voices, different relationships, different possibilities. The thing that surprised me most about the magazine was when I finished the first issue, I had the horrifying realization that I had to start on another one. It was something where you could hang out and be artistic and bum and complain about not having any money, it's just running constantly.

Each collaboration for me has been completely different. When Fred and David (from Joe Beef) and I were doing the book there was an inherent ESP because of our so many years together. We were all on the same wavelength about pretty much everything—the voice, the photos, the style, the layout, the humour. And so the spirit of the thing resounds. But I was working with friends here, so it was the most emotional book to date for sure.

When I did *The Family Meal* for Phaidon, that was more one of a one-off, gun-for-hire, professional experience. And then this new book, *Le Pigeon*, is again with two guys. I'm always saying I just can't wait to do a vegan book with women, like ten women. I just want more estrogen because I'm always with these crazy animal-like lumberjack men getting into dark situations...

But I guess this is my destiny. Anyway, with these Le Pigeon guys, I didn't know them very well and I had to travel between London and Portland a lot. A nice friendship blossomed, as it does when you're spending 12 hours in someone's kitchen.

I wrote most of *Le Pigeon* in Gabriel's voice, which as Peter says, that's what you do—what he said about the ghostwriting, that's what you do most of the time.

Naomi: You're surrogate parents. That's what you're doing.

What we do is pretty niche. One thing I'd like to ask is how you got into writing cookbooks.

THE TOP JOB

He has it.

He had it.

He wanted it.

The best political writing of the season.

Random House Canada www.randomhouse.ca

Jennifer: I got into it kind of backwards. I was doing a lot of food styling, styling a lot of people's cookbooks, and some of them were good and some of them I didn't think were that good at all. So I thought, if these people can do a cookbook, so can I. Then I thought about it, and I decided to do a book that had more that just recipes in it. That talked about the links to history and culture and different parts of life, because food is not out there by itself. It is a part of history, a part of culture, part of a time, it's a part of different people's lives. I wanted to put that into my books and I guess then I put myself into that niche, doing books like *Bones* and *Fat* and *Odd Bits*. It was important to put things in a historical context as well as in everyday context.

Naomi: I guess I'd say I got into cookbooks as a way of making a living while being able to be out in the world, being curious. I really like understanding how things work in people's lives. For me, food as a product is not nearly as interesting as our relationship with it and the context in which things happen.

So the first book that Jeffrey and I did was about traditional flatbreads, and that arose when we were bicycling from Western China into Pakistan, and people were living on mostly flatbreads. And you know they were eating over a kilo, two pounds of bread per person per day, the adults. Flatbreads stacked, lovely naan cooked in tandoor ovens. So we came up with this idea for a flatbread book and had to figure out how to actually get from the original idea to somebody wanting us to do the book, and somebody thinking the idea was good. That took us to writing articles for food magazines to get credibility. We also self-assigned ourselves trips to various places until we felt that we had enough credibility and knew enough that we could say, "Yes, this is an interesting topic and you should want to do this book." It was viewed as a very odd subject when we did it, and it came out in '95.

Really for me, it's about explaining meaning, context, and technique. And the goal is also to always to make the other, the foreign, the person in another culture or the food you haven't seen before, less other. To give people a relationship to something that they didn't know before. I think from there you get respect and it's a way of creating a table that everyone can sit around and communicate across.

Peter: And you have definitely succeeded in that. One of the big reasons I got into writing cookbooks—I mean, I was a fan. I really learned how to cook from cookbooks, I was a directionless acid freak until I found cooking as something to do. It was the first thing in my life I had ever figured out, that if I learned the system, by putting all these pieces together, I could actually do something with it. If you learn the technique, then you can apply the technique to food and make dinner. That was so simple and stupid but really important to me when I was 20 years old.

Jennifer, you've done *Bones*, *Fat* and *Odd Bits*. What's the next fascination?

Jennifer: I'm moving out of the carnivorous realm for a little bit. Actually, I'm tackling some vegetables. I'm working on a book that'll be out in September 2014, I hope. It's on the topic of bitter, and by that I mean the taste of bitter. Because I am so

sick of sugar and salt and umami and everything else. Bitter doesn't get the respect it deserves. I think that people don't understand bitter, and I think we need more bitterness in our lives. Maybe it's the fact of my age that I like this topic, but it's a fascinating topic and there's a lot of ways to introduce bitter into cooking without making the food that you are eating bitter.

There've been a few books about this, and it's also interesting to uncover the way we actually taste things and the different senses. It's not just our nose and our tongue, there's a lot more going on. It's our eyes of course, it's our sensory system, it's how the food sounds, it's the background where we're eating it. All these I hope to weave into the book as well, so people will think when they're cooking about the tastes, the flavours, and the combinations they are putting together—so it will give people a window into this world of bitter. They can start with something like dandelion greens or turnips and then move on. And just think about adding bitter even to a dessert, as simple as taking caramel to the perfect point where it's beyond sweet, but it's not horribly burnt—that makes a perfect caramel if you take it to the right point. So that's what I'm working on at the moment.

Naomi, am I wrong to think that Burma is the book you've had the most success with to date?

Naomi: No, yes you are...well no, I don't know! It's too early to say. It certainly had a nice splash because of the timing, and that was a lovely treat. It was great timing that things had turned better for the people of Burma just when the book was coming together. The people of Burma could've had this good luck 40 years ago and I would not have complained.

The next thing I'm taking on is in a slightly different part of the world. A little drier, cooler, and my working title is *Persian World*—I want to look at the legacy of Persian culinary tradition. Of course, it's very old, in a region that spans the Caucasus and Western Central Asia. I've just come back from Georgia, Tbilisi, ex-Soviet Georgia, and I'm trying to get to Armenia, Azerbaijan, Iraqi-Kurdistan, Kurdish Iraq, and hopefully to Iran, and just make those cross-linkages. It's a very rich heritage and people don't realize how many of the things, the flavourings especially, travel all the way into Mughal food and Moroccan food—the combination of a tart fruit with meat, for example, which is very Medieval. That starts in a Persian aesthetic 2,000 years ago then moves out. It's not that I'm planning on always talking about ancient times, I just want to put forward these smaller, somewhat hidden, quite incredible—Georgia is a great example—culinary cultures that have amazing things to teach us.

NYRB NEW YORK REVIEW BOOKS

PIERRE REVERDY
Edited by Mary Ann Caws

The simple and the sublime coalesce in the works of the great Pierre Reverdy, comrade to Picasso and Braque, peer and contemporary of Wallace Stevens and William Carlos Williams. Featuring the work of distinguished translators, such as John Ashbery, Lydia Davis, and Frank O'Hara, *Pierre Reverdy* collects the essential poems of one of the most mysteriously satisfying of the twentieth-century poets.

NYRB Poets • Paperback • $12.95 US / $15.95 CAN

A SCHOOLBOY'S DIARY AND OTHER STORIES
by Robert Walser

Introduction by Ben Lerner • Translated from the German by Damion Searls

Walser's careening, confounding, enticing voice mesmerizes the reader throughout the more than seventy odd and marvelous stories brought together in *A Schoolboy's Diary*, most never before available in English.

NYRB Classics • Paperback • $14.95 US / $17.95 CAN • Also available as an e-book

THE BLACK SPIDER
by Jeremias Gotthelf

A new translation from the German by Susan Bernofsky

Unforgettably creepy, Gotthelf's tale of horror, cruelty, and the macabre in a remote Swiss village can be read as a parable of evil in the heart, or of evil at large in society—Thomas Mann saw it as foretelling the advent of Nazism. For more than a century, *The Black Spider* has captivated and chilled readers with its menacing vision of cosmic horror.

NYRB Classics • Paperback • $12.95 US / $15.95 CAN • Also available as an e-book

THE SKIN
by Curzio Malaparte

Introduction by Rachel Kushner • Translated from the Italian by David Moore

This is the first unexpurgated English edition of Curzio Malaparte's legendary tale. *The Skin* begins in 1943 in the devastated city of Naples, and paints a subtle, cynical, unnerving, conniving, and astonishing view of a world gone rotten to the core.

NYRB Classics • Paperback • $16.95 US / $19.95 CAN

THE BRIDGE OF BEYOND
by Simone Schwarz-Bart

Introduction by Jamaica Kincaid • Translated from the French by Barbara Bray

A multi-generational tale of love and madness, mothers and daughters, folkloric wisdom and the grim legacy of slavery, set on the French Antillean island of Guadeloupe. "There's magic, madness, glory, tenderness, above all abundant hope." —*Financial Times*

NYRB Classics • Paperback • $16.95 US / $18.95 CAN • Also available as an e-book

Available in bookstores, call (646) 215-2500, or from www.nyrb.com

A biweekly podcast on the arts, culture and current affairs, produced by Hazlitt. Hosted by Anshuman Iddamsetty.

Find The Arcade by Hazlitt on iTunes, Soundcloud, and at Hazlittmag.com

Guests Past and Upcoming: Art Spiegelman, Wire, Claire Denis, Margaret Atwood, Chimamanda Ngozi Adichie, Choire Sicha, Killer Mike and El-P, Marisha Pessl, Douglas Coupland, Jhumpa Lahiri, Ronald Deibert, Kiese Laymon, Charles Montgomery, Chip Kidd.

Editor's Note

About half of what you'll find in here has been previously published on the *Hazlitt* website—consider it a sampler of our greatest hits and seminal tracks. The rest is original work. In most cases, we've paired up our writers with artists and photographers we love and commissioned new visuals.

Making this book gave us the opportunity to involve some collaborators we've long admired—from designer (here art director) Jeremy Laing and poet Patricia Lockwood to artist Adrienne Kammerer. It also made us look back at all we've published in just over a year, which only sharpened our sense of what we still want to do.

We hope that our inaugural print edition does justice to the breadth and quality of what we publish day in and day out—in addition to our podcasts, videos, and e-books—while also hinting at some new directions. And we hope you enjoy these writers and their stories as much as we do.

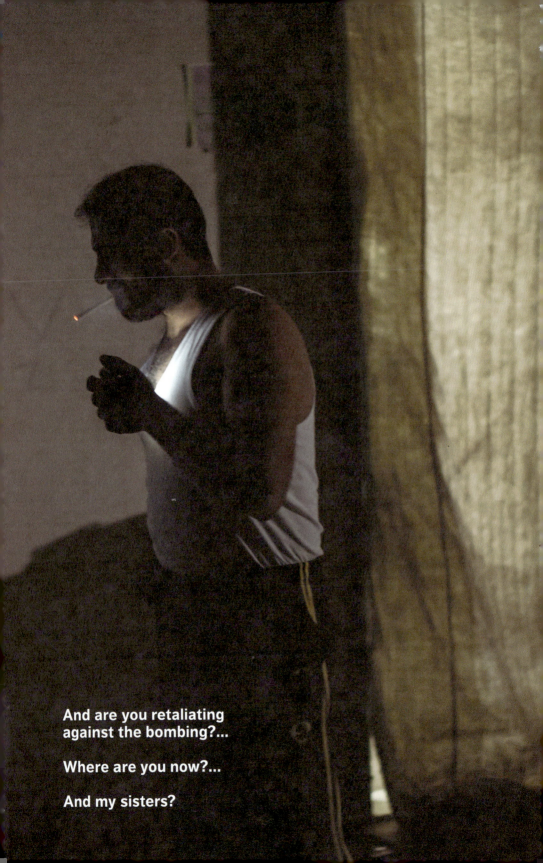